Swimming Underground

Swimming UNDERGROUND

my years in the warhol factory

MARY WORONOV

JOURNEY EDITIONS
Boston • Tokyo

Published in 1995 by
JOURNEY EDITIONS
an imprint of Charles E. Tuttle Co., Inc.
153 Milk Street, Fifth Floor
Boston, Massachusetts 02109

LIBRARY OF CONGRESS CATALOGING-IN-PUBLICATION DATA

Woronov, Mary.
 Swimming underground: my life in the Warhol factory / by Mary
Woronov.
 p. cm.
 ISBN 1-885203-21-7
 1. Woronov, Mary. 2. Motion picture actors and actresses—United
States—Biography. 3. Artists—United States—Biography. 4. Warhol, Andy,
1928– . I. Title.
PN2287.W67A3 1995
791.43'028'092—dc20
[B] 95-31071
 CIP

2 4 6 8 10 9 7 5 3

Design by Kathryn Sky-Peck
Edited by Denise Bigio

Printed in the United States of America

CONTENTS

For
Ondine, the Pope

ACKNOWLEDGMENTS

MY THANKS TO Denise Bigio, my editor, my friend, and someone who has understood this book from the beginning and is responsible not just for its development but for discovering its very core; to Amy Inouye for proofreading and a thousand other ways in which she helped; and to my publishers, Peter Ackroyd and Roberta Scimone, for believing in me and listening to me.

Also I would like to thank the past, all my friends at the Factory, the ones who are dead whom I can never talk to and the ones who are alive whom I pestered with phone calls: Nelson Lyon, Louie Walden, Billy Name who gave me his beautiful photographs, and Paul Morrissey, Donald Lyons, Ronnie Tavel, and Gerard whom I didn't call. Special thanks to Andy Warhol for creating the *prima materia,* and to Stephan A. Hoeller for explaining it. Also to Michael Tolkin for his help and friendship, and to Mrs. Ann Janss for her support.

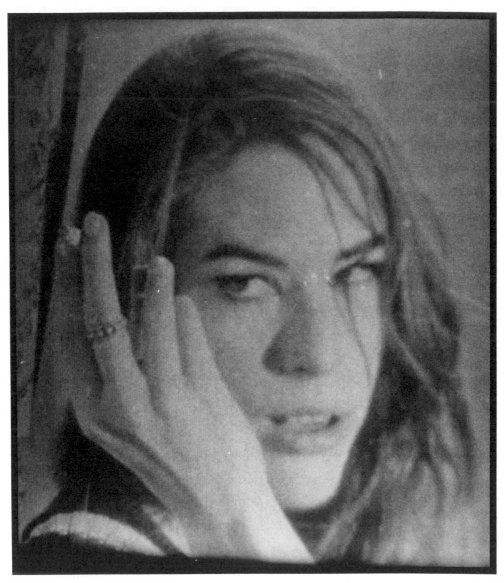

Mary Woronov in Chelsea Girls

PROLOGUE

I COULD TELL BY everyone's expression that she was swimming out too far, so far out that a crowd gathered to point, and the lifeguards were yelling for her to come back. I started to cry as the waves of Jones Beach crashed down on the cement sand, slamming shut like steel doors again and again. I worried because if my mother didn't come back, who would take care of me? I was only four years old. But she always returned a hero, laughing and hugging me with an odd excitement I began to envy. Mom was such a great swimmer I couldn't hate her, so I hated the ocean instead. The only reason I learned to swim later on was my painful but mute longing to be around boys. One summer I had an excruciating crush on my cousin Nicky; he and his friends played on a sandbar that was too far out for me to get to. It looked like such fun, to be way out in the ocean but only up to your kneecaps in water—I had to get there. My plan was to swim out with Mom late in the day when no one was looking in case I couldn't make it all the way. If I did make it, then the next day I would swim out with my cousin, no problem.

I had to pester Mom into swimming with me. I knew I shouldn't be tormenting her, that she was in a fragile mood. She and my new stepdad had had one of their really bad arguments, which was why we were visiting indefinitely with my cousins on the Long Island Shore. It was kind of sad to see Mom reduced to sitting in the sand, staring at the water with red eyes, her lower belly just beginning to pop out of her swimsuit, but I was a little sand scorpion that day, stinging her again and again. I had to have my way, it was very important that I reach that sandbar.

I taunted her with being too old, and getting too fat. I dared her, and of course I begged her, and then sulked at the other end of the blanket as people went home and all my hopes started sliding with the sun down an empty sky, so when she said "okay" I was shocked. Suddenly the water looked too cold for swimming, but it wasn't. It was warm, warmer than the air, and as we waded in it seemed to grow calm and lap about my mother's calves like an old friend who had waited a long time for his second chance. Mom's legs and arms were the same, only her waist had thickened, but as she walked into the water this weight, which she could never diet off, seemed to disappear inside her, and she looked animal again—just like when we were at Jones Beach, only this time I was going with her.

2

I danced ahead of her, threw myself into the water. When I came up for air she was watching me, her eyes glittering, then the first wave came, she dove under it, and we started swimming. As we swam out, I kept ahead of her, but I was getting tired. We swam farther out than my cousins or anyone had been before and still there was no sandbar. High tide had covered it up. Suddenly the world tilted, and all the water was rushing back out to sea, taking Mom and me with it.

A riptide. Mom figured it out first. "Go back," she yelled, "we're too far out." I turned back, but the shore was so tiny and far away it scared me, and when I swam towards it, I seemed to drift backwards. I couldn't make any progress. I stopped swimming to catch my breath, and the current immediately separated us. My mother swam over to me, her face inches from mine. I couldn't believe it, she was smiling. Grabbing me by my ponytail, she yelled, "Float on your back and kick. I'm going to pull you."

I rolled over and faced the sky. We were going to die. But seeing the sky calmed me down. Mom's body flattened out alongside me and she began to swim hard and deep, in an old familiar contest. Time went by, me watching the fading sky slide around and concentrating on kicking death away, and her pounding ahead in long even strokes, ripping

the air out of the twilight and burying it in the water—over and over again—till I was sleepy and didn't feel like kicking anymore—didn't mind death lapping at my limbs.

Maybe I closed my eyes and went to sleep for a little while, I don't know, but when I opened them the sky was black and so was the water. Black and still for miles, it rippled white only where Mom's hip and thigh broke the surface, like the water in a sailboat painting, I thought. Then I realized she wasn't struggling against the water; on the contrary, it seemed to organize itself around her, and push her forward, caressing her like a lover would. Or maybe, perhaps, she had turned into a fish—her throat slit open in two bloodless red gills, her belly a cold metal white, her eyes lidless and staring forever. I tried to picture kissing her goodnight. It would be a little scary at first, but at least we would never drown, nor could we ever return to the land. We would roll forever on the back of this watery beast, slipping just underneath the darkening sky.

No, we were going to die. No one can swim forever. She was just my mother, she wasn't that strong. Why, even I could outrun her. I wanted to talk to her before the beast pitched us off his back and swallowed us. I wanted her to stop swimming now, and say something to me, not just drag me behind like some stupid dinghy.

4

"Mom," I began our last conversation, "Mom, we're not going to make it. We're going to die. You can let go, Mommy, we can't" She didn't hear me. She was in another world, another rhythm that wouldn't give up, that was turning dark water into motion and life, as stroke after stroke she linked together an iron chain that pulled me from the water's lips just before they closed over my face. Mom was actually teasing the beast, pulling his dinner out of reach before he could suck it down, as he pushed her forward for another bite.

Hope shuddered inside me. Like the doomed mortals in my Greek mythology book, Mom was planning to outfox a god, a big powerful god—the ocean. Realizing she couldn't battle him, she had picked a destiny far down the coast, and now she was swimming across the current. Pretending to swim with him out to sea, she was inching towards the shore. Pretending to love him, she was planning to betray him. She swam in grim silence, and I tried not to be noticed. I even smiled in case he was watching, because if he found out, he would kill us. But it worked. He fell in love with her aching arms, her tireless legs brushing against his cheek, he couldn't bear to pull her down just yet, until it was too late, and the quiet shore suddenly was there to prevent him from finally grabbing her. Angry and hurt, the

water stood up and smashed over our heads in a rage, splitting us apart. "Mary, stand. You can stand," I heard Mom yell at me. My feet hit the sand just as the next wave tried to bury my head in it, and my mother and I tumbled out onto the shore.

Everything was a mess. My cousin was running down the beach with two lifeguards, everyone had flashlights, some other people were struggling with a boat way out in the water, and up ahead sharp black rocks I had never seen before split the waves into seething foam. I started shaking. I just couldn't stop no matter how many blankets they gave me, but Mom, she was happy again, laughing like she used to on Jones Beach, her body glistening white against the fallen night. It was like old times—people fussing over her, me feeling pathetic, worried over nothing. I hated it. Every time she looked back at me huddled in my blankets, that strange smile would curve her lips, her eyes would glitter again, and my gratitude at being alive shriveled. She knew what she was doing all along. She had done it before, swimming out too far, scaring people so they paid attention to her, and now letting me swim into a riptide so she could rescue me and be a hero. I hated her. My cousin came up to me and said solemnly, as if it was my fault, "You had better not go to the sandbar again." That was the final straw.

As they recounted the incident again and again over dinner, and Mom was getting big laughs telling them my speech about how she should let go because we were going to die, I called my new father and told him my own inventive version. I even started crying mid-description and had to hang up. He was there the next morning and they had their worst argument yet. I once read about a horse that couldn't be broken until a cowboy cracked a bottle of beer over its head. Its head was so strong it didn't hurt but the horse thought the beer was its blood and its spirit was broken. Mom never swam again.

The strange thing is that nothing really changed; I continued to have my own warped interpretation of events, and Mom refused to let anyone stop me from swimming out too far. Throughout my time with Warhol she insisted that what I was doing was artistic. It wasn't until I left the Factory that she turned around and stabbed Andy right where it hurt, in the pocketbook—suing him for not paying me when *Chelsea Girls* started making money. But that's her story. I can only tell you mine.

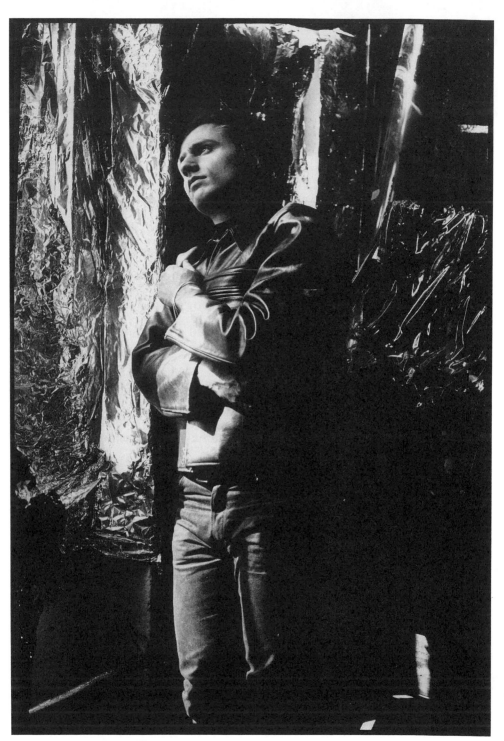

Gerard Malanga

Chapter 1

Mercury

’m sitting in a chair. I've been sitting here for two months. I have four more months to go, or I could stay here forever, just continue sitting in this chair for the rest of my life—and don't think for a moment I'm not capable of doing it. All I have to do is make the decision and there will be no future. The screen will just go blank. I am that determined.

You may ask what I do all day sitting in this chair. Well, I pack. In my mind I lay things out and begin to pack them in an organized fashion. I have always been a packing fanatic and longtime sufferer of suitcase dreams. It isn't the clothes that are the problem (I wear only black), it is the emotions—which to take and which to leave behind. I'm just becoming aware of the animals that share my head with

me. It's a regular zoo up here. There is Violet, my dog—my
violent temper—the kind of thing you get a reputation for,
and I must also confess to being the abused owner of a rage
rat. This rodent is a voice in my head that never shuts up. I
don't know how I acquired it. I suppose it was given to me
at an early age by some malicious adult, or perhaps every
head comes equipped with one—you know, the "rodent
included" plan. I've already packed these two in their
traveling boxes; others are too prehistoric to catch, nobody
would want to go into the black waters where they live. And
there are also animals I don't want to catch; rather I'm
afraid of them catching me, like the coyotes who carry
insanity like the plague. I'm afraid they will find out where
I'm going and follow me. Every time I find a new animal,
like my party squirrel or my comedy crow, I give it a cage
and a feeding schedule. And of course there are the
rabbits—little habits that I've stuffed into every possible
space in my suitcase—habits of speed, junk, pills, and any
other poison I can get my hands on. All this I can do from
my chair so there's no reason to move yet.

Believe me, I know perfectly well what I'm supposed
to do—get married and lay eggs. In my case it would be
eggs because, having misplaced most of my genetic code,

the only thing left on my reproductive map is an old rubber pterodactyl diagram. But so what, I never exhibited any mother-type qualities anyway. All of my dolls ended up on the operating table for scientific experimentation, resulting in deformities so ludicrous they were executed on sight by Mom until she declared that I could only receive stuffed animals as gifts, animals I loved and talked to endlessly. Misunderstanding my imaginary operations, my stepdad, who was a cancer surgeon, started taking me along to watch him operate. After I saw him remove a lung, I was depressed for a month. But although the real thing repelled me, I never lost my passion for operating. However, it wasn't until I hit college that I got a chance to perform on the human-skin package, and naturally the first guinea pig was myself.

Not being as keen on love and marriage as my peers at Cornell, I did talk myself into making one lame attempt— his name was Carl Bezzari. If I had married him my name would have been Mary Bezzari. I know, it sounds like a trapeze act performing at the local suburban circus of Westchester. Besides being as interesting as a plate of cheese, Carl was reasonable; for instance, since I was a virgin there were other reasonable things he decided we could do

instead of intercourse, and after my first blow job I realized sex was just a lot of hard work. It certainly ripped the romance right off the walls. Carl was actually pleased I was a virgin—so pleased he would sit around and tell me what a great time we were going to have taking my cherry. In fact, he made me so pissed off about my condition that I finally decided to take my own goddamned virginity, and off I marched to conduct my first real operation.

While vacationing in a sullen rage with my parents and brother at Grossinger's Hotel during spring break, I decided on a one-night stand with a complete stranger, namely the busboy waiting on our table, the one who kept smiling at me over his slanted tray of dirty dishes. I thought sex was like getting a tattoo on the inside, after which my body would be altered physically and socially. That's what I wanted, the mark that said I was a woman.

When sailors get tattooed they are usually very drunk, so I made him buy a small bottle of Wild Turkey, but I wasn't drunk the night it happened; the wind was crashing about in the Catskill treetops, stumbling around in the dark without any moonlight. As we cruised through the blackness under the buzzing telephone wires, the inside of his Riviera glowed like a spacecraft, making his skin seem very white

and alien. Close up, he smelled of Canoe and gasoline from his beloved car. I couldn't tell what he was thinking. His hair comb was so complicated you forgot he had a forehead, much less thoughts behind it, and looking at his face I hoped I would never see this boy again. I had to make sure I never saw him again; never told him he was the first, so he couldn't boast about me like his curling lips were doing now about the wives at the hotel who expected him and his friends to fuck them. He showed me a new watch that one of them had given him, and it glowed in the night, hanging on his wrist out the car window, sailing along beside us like a little flying saucer.

But I did see my busboy again. All I had to do was close my eyes, and I could see his head and neck and shoulders as they moved with a passion that I didn't feel but tried my best to emulate. After we made it, I curled up in his arms and fell asleep like a kitten. He had to make me get up and get dressed, all concerned about getting me back to my parents' hotel room before dawn. To my horror, I didn't want to go. I didn't care about anything else but drifting in his strange arms on the dark ocean that swelled and trembled inside me, an ocean that I feared could drown me. When I got back to the hotel room, my brother

watched me climb into bed so intently that I thought he
was counting my limbs to see if I was missing any. But after
I questioned him he said it was the way I undressed, it was
so complicated, as if I was trying to hide something.

I was hiding something all right, my tattoo, and it
remained my secret. Back at Cornell, I made sure the
strictest measures were taken so I would never drift on the
black ocean again. Sex was banished from my kingdom, it
was too confusing. I strangled my little unwanted desires,
kept them in a sack out of view, and only when I was
alone—a mad young Dr. Frankenstein—did I let them out
and make them flop around like dead kittens on
electroshock. Mercilessly I continued my experiments,
reaching forms of unnaturalness that made even me uneasy.

In experiment after experiment I got my girlfriends to
fuck the boys I was attracted to; boys who had pet habits of
their own, rabbits so big that they had to move to the
nearest motel and spend all day dragging illegal bags of
kibble up to their messy rooms. It wasn't just the drugs,
these boys made my tattoo shiver. I was especially interested
when my girlfriends were repulsed by them at first, the rich
girls who proved to be really trashy underneath and the
intellectual girls who were really hungry inside. My most

successful experiment was getting my undegenerate roommate Jane to ball David Murray so I could live with him; I really liked him and I knew he wouldn't stick around unless someone was putting out.

When I first introduced them I had no idea if they would even get along. Jane wrinkled her nose up, so I said Murray was a poet from New York City, do wa ditty, when in fact he was a townie from the other side of the tracks— tracks he loved to get fucked up on with cheap Cherokee wine and speed and me, you know, à la Jack Kerouac. Oh, he had been to New York all right, but I think it scared him, that's why he was back here.

"You mean he doesn't even go to Cornell?" Jane whispered. She wasn't seeing him in the same romantic light that I was.

"Look, I said he could spend the night. We'll just get high and he can watch us paint."

Although Jane and I covered the walls with paintings in progress, we were still both in constant danger of failing art. Concentration was not a priority, getting drunk while the sun spread across the local barroom floor and Motown poured like honey out of the jukebox, that was a priority. From our bar stools we decided we were best friends

because we were opposites—she was short and I was tall;
she was always torturing and chopping her hair while I
swung mine about like a flag; she played the innocent, I
played the heavy—but all we really played was hookey.

Now she was being brave because Murray definitely
wasn't her type. I knew her type and I hated them; the
preppy boys in their trust-fund loafers. Murray was
sandwiched between a pair of pointed black cowboy
boots and hair like someone had scribbled all over his
head with a greasy black crayon. But soon Jane was
laughing at everything he said, while I tried to finish one
of my paintings. Murray produced a tiny bit of dope and
two or three poems out of his worn pea coat as he talked
stories about New York and famous people like Andy
Warhol. I had heard them before but Jane was impressed.
Plain Jane as I used to tease her. Soon they moved into the
bedroom.

"Mary, come on we want you to play too," Jane's
voice was muffled under the pillows.

"Mary, you're not mad at me, are you?" Murray came
creeping out of the bedroom sheepishly.

"No, no, Murray, but you better put some clothes on,
it's cold."

"I really like her. Why don't you come in there with us, and make it a threesome?"

I had to put my foot down here, and after pretending delicate shock for Jane's sake, I told Murray not to be so fucking greedy. As soon as he realized I wasn't interested, they settled down to some serious sexual activity, and I got my wish—Murray started living with us. At first it was like having two pet otters in the bed next to mine, later it was more like living with a porno film. I could leave any time, get coffee, come back and finish another reel, then fall asleep wrapped in my blanket tight as a pervert in his raincoat. Sometimes I wasn't sure if this experiment was what I had had in mind, watching them scrapping and panting in bed night after night. Was I torturing or entertaining myself? Did I love them or hate them? It was so blurry. I fell asleep and by the time I woke up I was sitting in this chair. Cornell had forced me to take a six-month leave of absence. It was either that or fail art, which was unheard of.

I'm not sure why being in a chair is better than a bed, but my mother insists that I get up every morning and get dressed. Mom always had a lot of regulations. For instance, she would beat me to death if she caught me smoking pot,

but she gave me as many of her little speedy pills as I wanted. To her, pills weren't dope, they were medicine to make one normal, and normal was the goal of all the adults in my world. Consequently, we always used drugs. That's what my well-rounded family did, Dad being a doctor and all. When Mom didn't clean the house fast enough, Daddy put her on speed after diagnosing an underactive thyroid, a disease common to tall beautiful blonde women in dark little marriages. Let's face it, we all liked her better high, she did everything for everybody; elaborate school reports for my brother, the bookkeeping and taxes for Dad. At three in the morning I'd find her curled under the yellow light of a single lamp in a darkened living room surrounded by an even darker city reading *The Rise and Fall of the Third Reich*.

"Mom, why don't you go to bed? It's late."

"Uh huh, I will . . . in a minute."

"Mom, you read that book last year, don't you remember?"

No answer. She seemed small and far away, but I never hugged my mother. The ocean lay between her arms and embracing her was the equivalent of entering a maelstrom without a life preserver; the floodgates could open, mindless

black emotion pour in, and I would be swallowed up by the sadness of her and me and life. Of course I didn't touch my stepfather either, but the reasons were quite different, there was certainly no water involved. He was a desert in the middle of which sat a tightly coiled snake. I never kissed him, afraid that the snake's head was just on the other side of his lips, and if I opened my mouth it would slither inside me and I would never be able to get it out. He was very charming in spite of a slight limp from polio. Women loved him, even my mother's best friends. I could tell by the way the maître d's smiled when we went out to lunch that they were used to seeing him with different women, and the only reason he was embarrassed was because I was a little too young. Most of those emergencies at the hospital were blondes or brunettes. To me, Dad's limp was a warning that he wasn't so charming underneath. Someone had to stop touching him and I decided it would be me.

My one ally, my little brother—keeper number two of all the houses we built; in the woods, out of boxes, and under the bedclothes; the second in command of all the legions we force-marched across the living room rug—has turned traitor on me. Yesterday morning he announced that having discovered life was much better without me, he

couldn't wait for me to go back to Cornell. I didn't answer
him, but I agreed. There was no place for me at home
anymore, and he was the only one who had the guts to say
it.

There is something else I can do from my chair. I can
see the future. Before I ever returned to Cornell I knew I
wasn't supposed to be there and somebody would come and
get me out. His name was Gerard Malanga, a poet friend of
Murray's from Manhattan, but he was different; sex didn't
seem to be an issue. Gerard just wanted to film me and be
filmed with me, that was the concern and it was an all-
consuming one. When I first saw him I thought he was
beautiful, dressed in black leather with a Bolex camera in
one hand and a bullwhip in the other. Obviously he loved
being stared at. Life was a twenty-four hour stage; even
when no one was looking, he acted like he was being
watched—it was eerie.

Gerard insisted on shooting a film of me that he later
called *Mary on Triphammer Bridge*. As I walked across the
bridge, I felt as if I were walking down the aisle towards my
new husband—not Gerard, but his camera—and that was
okay with me. Letting myself be used this way was far more
exciting than my tired old experiments.

I didn't see Gerard again until Cornell started sending my class on field trips to Manhattan to visit famous artists' studios like Rauschenberg's and Oldenburg's, but Warhol's was as far as I got. Andy's studio was called the Factory and instead of the pristine white walls and bright lights of the other studios, it was dim and dirty-looking, as if it were underground. The only light was reflected light coming off the tinfoil walls, making everything unreal and flickering. Out of the gloom, Gerard walked up to me ignoring the others and flashing his blond hair and insolent ease. I was happy to see him, and I felt special as he led me to a little silver couch. "Andy's doing something called *Screen Tests*," he whispered in my ear, "You just look into the camera for fifteen minutes. Murray's already done one, he was great. Maybe I'll get Andy to do one of us together, we could set it up right now. . . ." I watched my classmates file into the elevator as they started back to Cornell without me. They looked like foreigners now, and as the steel doors shut on their faces I forgot I ever knew them.

Staring into Warhol's camera for fifteen minutes was as serious for me as baptism, and afterwards like a new convert I couldn't stop talking about what a genius Andy was; the way people's expressions changed in *Screen Tests*,

making it a psychological study, the idea of conferring immortality onto unknowns, the deafening speechlessness of it. What I didn't realize was that Gerard was the silver hook of a very different fisherman and I was being reeled in. He brought lots of girls back to the Factory, all of them beautiful and excited, but I didn't care, I was mesmerized by this underground, and grateful to its messenger for choosing me. I started taking the Greyhound bus from Cornell to New York as often as I could.

Jane thought these trips were very glamorous. Only one person tried to stop me—Carl Bezzari. Blocking my way with his beloved motorcycle, which he was taking on a trip to Mexico before he joined a very wealthy law firm, he wanted to know if I would be waiting for him when he got back, and if I was ready to give up those Warhol people who were making me hard and unattractive. I pushed him out of my way, yelling at his frightened face.

"No, you're not leaving me, *I'm* going. I'm going to New York to do movies with Andy Warhol, and waiting for your sorry fuckin' ass doesn't really fit into my schedule. Anyway, I just found someone who doesn't care if I don't want to fuck him, who just wants to take pictures of me, which is a whole lot fuckin' easier on the body and certainly just as exciting.

24

"And while we're at it, fuck Cornell before they drop me again, and fuck being an artist when I can be a part of art itself in Warhol's movies, and immortal instead of dead and married." I was still screaming to myself in a rage as I walked into the Ithaca Greyhound station for the last time. I was dropping out. I had to—Warhol had asked me to go with them to California, and getting a stupid degree was not going to stop me. I bought a ticket for New York and waited. . . . Bus stations are so lonely, and always freezing; they are the acid test of a traveler's determination.

On the bus I tried to picture the future again as I had seen it so clearly from my chair, but the windows of the bus remained blank; the only things that appeared on them were the frightened faces of my animals, each one huddled in its black traveling box, hurtling with me through the anonymous landscape. I stared straight ahead at the highway until the bus was a camera eating the black road like a ribbon of film, while the headlights projected my shadowy future on it. I stared until I was sure that gravity was wrong and we were not going along but rather dropping down, down under the ground.

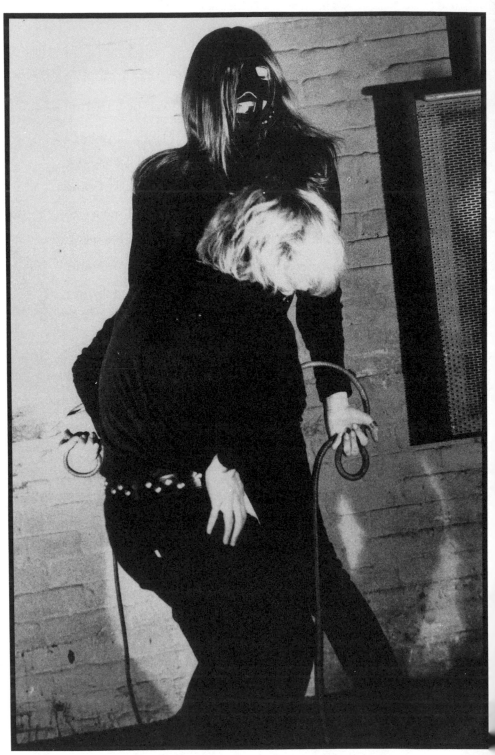

Mary Woronov and Gerard Malanga in "The Whip Dance"

Chapter 2

HE
TRIP

erard raised the oversized pink plastic syringe above his head and slowly started spinning till he dropped to one knee. I held my arm out to him, my hand over the inside of my elbow as my lower body twisted to the rhythm of "Heroin." On the ceiling an old mirror ball turned, its spots of light jumping from one dancer to another like lost souls looking for a host. The enormous faces of demented queens and ravaged superstars filled the wall behind us as if they were giants peering into a box of dancing Lilliputians, but their distorted voices and stunned expressions were only the projections of Warhol's experimental movies. Dwarfed by Mario Montez's lipstick-stained teeth and looking like insects that had just crawled out of his mouth, the Velvet

Underground played in their wrap-around shades. This was the Dom, a Polish dance hall in the East Village where Andy put on his performance called the Exploding Plastic Inevitable so that the Velvets would have a place to play— God knows nobody else would hire them.

Suddenly Gerard danced away from me, whipping his blond hair about wildly, only to be drawn back as if struggling against his will, and we touched, but only briefly. Wanting was better than having, looking was better than being—it was the land of reflections. Like a self-declared Pygmalion, Gerard dressed me in black leather pants matching his, gave me a black whip like his to dance with, bought me bizarre armbands that looked like studded cat collars, and wrote me poems; poems which Andy said sounded like all the other poems he wrote to the girls he'd had crushes on. Still, I went everywhere with him. I fell asleep during Allen Ginsberg's chanting, I had nothing to say to Salvador Dalí, and I retained a stony silence while Warhol filmed Gerard licking my boot for twenty minutes as I sat motionless in a chair. Gerard always set up this kind of scenario either out of frustration because I wouldn't fuck him or because he was a throwback to the Catholic flagellants, and I always went along with it because these

30

bizarre rituals matched the suffering of my soul much better than all my experiments.

Amazed at how docile I was with Gerard, I started to get frightened when he took me to visit his surrogate parents, Willard Maas and Marie Menken. Coincidentally, they happened to live on the other side of Montague Street, right opposite my parents, and when we started showing up for free dinners I felt uncomfortably like the virgin you bring home to mom. Marie picked up on this. Swaying before us like a prophetic Sibyl, she would drunkenly yell, "She's a nice girl and you oughta marry her," as Willard and Gerard rolled their eyes and cracked jokes. She looked like my future in forty years; we both had the same big old Slavic cheekbones, and she towered over Willard just like I towered over Gerard. The whole thing was funny and too close for comfort. In spite of the fact that Willard was gay, Gerard said Marie met him when she was a virgin and never fucked anyone else, and here they were at sixty, drinking and shouting their way through dinner till she passed out. Once she crashed, her two pet Russian wolfhounds became vicious guardians, so if she fell between us and the door, there was no way we could leave until she woke up in the morning. But let's face it, I wasn't

scared of spending the night, or seeing myself in old skin and drunken rants, I was frightened because they loved each other so much they couldn't separate; because when Marie didn't get up one morning no matter how patiently her dogs waited, Willard sat in the dark and proceeded to drink silently and steadily for three days until he joined her.

Gerard held the syringe out to me like a priest holding the cross to a sinner and I responded by hooking my fingers under his belt buckle and slowly grinding my hips lower and lower down his body to the heavy pulse of the Velvets. He stiffened, turning the needle towards his own heart as if he were finally going to plunge it in, but everything was shattered by Ingrid who started frugging next to us like a giraffe. Gerard and I separated like lovers caught in the act. Luckily the song ended, and when Gerard split I turned on Ingrid.

Everyone loved Ingrid. But I didn't. I hated her. She was so eager to act stupid, like it was her job; actually she was Andy's invention to get back at Edie. Both girls had the same thin body with short dyed-blonde hair and big earrings, but Ingrid was Edie's opposite: ugly, low class, and stupid. It was as if Edie was Dorian Gray, and Ingrid was her portrait. After Edie's banishment, for reasons that I

never understood, Ingrid remained as a sad reminder of who wins in this game. Her last name was Superstar because without that label you wouldn't know she was one—and also, I thought, as a warning. She was what Andy thought superstars were—ugly, cheap, and annoying. Shit, the speed I took before the set was really kicking in, everything was so clear, I had completely dissected Ingrid Superstar in about three seconds.

"Ingrid, you can't dance up here, you're fucking everything up."

"Yes, I can. Andy said it was okay. And I'm sure it's cool with Gerard."

"No, it's not okay. I'm dancing with Gerard, you little skull fuck, not you, me."

"Let go of my arm, you're hurting me. Andy said I could take your place. I told him you wanted to leave, 'cause your dad is here. I thought you probably had to go with him."

"My father?"

"Yeah, he's over there talking to Andy. You know, I'm doing you a favor and you grab my arm like you're mad at me. You don't have the right to treat me that way, and I'm going to tell Andy."

"Shut up, Ingrid." I shrank back against the wall. I didn't want Ingrid taking my place with Gerard, but she was right, I didn't want to dance in front of my father either. Not the way I danced. The last time Dad saw me dance I was miserably being shoved across the prom floor by an extremely short boy who looked more like he was backing up a horse than doing the fox trot. He would never understand what I did with Gerard. What was he doing here anyway? I had told my parents I was going to California with Warhol, as the lead dancer in the Exploding Plastic Inevitable, and they had agreed—well, sort of agreed. Actually they had had a big argument over it, which Mom won; she said my being with a famous artist like Andy was an opportunity I shouldn't miss. Dad said it was horseshit.

I stared at the incredibly wrong picture of my father talking to Andy Warhol while Ingrid senselessly cackled in my ear. Andy looked like a third stage heart attack, but then he looked like that a lot. Besides being paralytically shy he was deathly afraid of confrontation. Now Gerard seemed to be stepping in and yes, yes, walking Dad to the door. As soon as Gerard got back on stage, I scrambled over to him to get the drift.

"Gerard, what was that about?"

"He didn't come here to see you. He came here to see Andy and me."

"For what? A liver transplant?"

"To make sure we'll take care of you in California. Of course, Andy freaked out. But don't worry, I promised your dad I would be responsible for you."

Instantaneously I felt reduced to a package. "I can take care of myself," I mumbled.

"You don't understand. This is between men, okay, so forget it," he sneered.

I had no intention of being just Gerard's girlfriend in California, I wanted equal billing, but the sound of "The Black Angel's Death Song" broke over our cars, and talk was obliterated. Our eyes locked as I swayed towards him, then snapped away as my arms opened for him, while my brain slid into automatic pilot and my body took over the controls.

We were not a hit in L.A. in spite of the fact that Andy showed his movies to Hollywood, the Velvets wrote new songs, and Gerard and I worked out routines as serious as Catholic Mass. In "I'm Waiting for the Man" I lifted weights; in "The Black Angel's Death Song" we swung

flashlights and stared into strobes; but my favorite was still
the S&M number we did to "Venus in Furs." Gerard would
go down on his knees to kiss my whip, then my wrist, then
lick the sweat on my neck where it trickled down like blood,
then drop to put his lips onto my boot, and on and on in
mesmerizing patterns.

Still nobody came to see us at the Trip, the tiny club
on Sunset where we were booked. Without the protective
shell of New York we seemed to have lost our magic. The
reviews were terrible: "The Velvets should go back
underground and practice," "They will replace nothing
except maybe suicide." On the third night the sheriff's
office shut down the club for disturbing the peace.
Meanwhile down the street, the Whisky A Go Go was
packed with the crazed followers of L.A.'s false rock 'n' roll
god, Frank Zappa, who mocked us, and whom we hated.
When we went to the Whisky I felt especially humiliated
because up above the door, trapped in a beautiful Plexiglas
box, an ecstatic blonde girl danced totally high on the bliss
of her own body. Her costume was mostly suntan, her own
special air and music were pumped in, and everyone
worshipped her. It was my image of heaven but someone
else was there instead of me.

While the Whisky angel squirmed in her box, we sank into L.A., the only city with two tar pits for a heart. Union rules said that in order to be paid, we had to remain in L.A. whether we performed or not. So Andy was talked into renting the same empty castle that every stranded band got stuck with and we prepared to wait it out. I figured at least it would be better than lying around a motel pool in sweaty black leather pants.

"Gerard," Andy insisted, "there's not enough room at the Castle for everyone, some people have to stay here." We were all at the Tropicana Motel, a fleabag compared to what I was used to with my parents.

"Fine, I don't want to get stuck in the hills. Mary stays here with me."

"Oh, but you didn't ask her. Mary, do you want to stay with us in a castle?"

The question had never come up before. In New York Gerard had no place to live; no one did. We were too high on speed to sleep, and crashing, shoplifting, and mooching were much more chic than getting a job or having your own place. When no one let us crash on their floor Gerard would take me back to my parents' place, but that was impossible here.

"I want to stay in the Castle," I answered. I could swear I saw a flicker of triumph in Andy's eyes, while Gerard's stare radiated such betrayal I started to burn. It was one thing to be independent, but to spring this public rejection on him was bad manners.

Gerard never mentioned it. Words had never been a big part of our relationship. We communicated like two animals; I could usually sense his feelings, but now he had pulled back his singed paws and I couldn't feel him anymore, except when we danced together. So we separated. Gerard stayed in Hollywood where they took acid, wore Technicolor costumes, practiced free love and other communal things, all of which terrified a poor easterner like me who rigorously used speed, only wore simple black and never did anything but mind fucking and a little S&M dancing.

I stayed with the rest of the exiled Inevitables moping and grumbling in the Castle. I got along with Lou Reed best; maybe because he never made a pass at me. Actually none of the Velvets had a lot to do with girls, and on tour Nico was the one I had to avoid. She was so beautiful she expected everyone to want to fuck her, even the furniture,

which groaned out loud when she walked into the room. I had seen chairs creep across the carpet in the hopes that she might sit down on them. Naturally I treated her like the plague, bunking instead with Maureen, the drummer, who was so frightened of me she wore her entire wardrobe to bed every night.

For weeks we floated in a dreamy nightmare, bumping into each other like the silver helium balloons Andy showed at the Ferus Gallery on La Cienega. They were Andy's good-bye to art, and at the opening he stood in the corner moaning, "Oh, aren't they beautiful? Gerard, why can't we get them to hover in the middle?" But I thought they were sad, trapped in that hot little room, and I began to hate L.A. for the swamp that it was. We were being drained of our power here. Any city that allowed the insanity of coyotes so near its borders was not to be trusted. Our pale skin and black clothes were no longer threatening under the relentlessly happy California sun. We were reduced to wallflowers; even Andy had nowhere to go.

Determined to have my own good time, I let a nameless hippie take me to see a happening at a small college for rich kids. I should have known better when I

looked into his eyes and saw nothing but the back of his empty head, a definite sign of LSD erosion. After five minutes in the car I was lost with no hope of getting back; the freeways slithered all over the place like black snakes swallowing great distances when you least expected it. When we finally arrived, the college turned out to be a beautiful mansion in the middle of a tangled wood, beautiful except for the dog shit in all the rooms and halls. These people were really dirty. Most of the students slept in the woods in hammocks and tents and wigwams. When I saw the swimming pool I had five whole minutes of ecstatic anticipation before they informed me that the last three swimmers had caught gonorrhea in their eyeballs, and it would be better if I went with them on a mushroom hunt. Fuck that. I wouldn't be caught dead picking mushrooms, and later on I was thankful I had refused when I saw all of the students flopped out on the grass groaning and puking their brains out while their dogs trotted into the house to take their evening dumps. No one remembered the brilliant invention of the stomach pump, which can be seen and even used at any ordinary hospital. Then, as things became stranger, I realized that puking was not the only effect of the mushrooms, these people were seriously high; high in

ways I didn't want to think about. I chose the roof to wait
it out, partly because I knew they were too high to get up
there and partly because I wanted to watch.

I was not alone. The California night was so clear it
looked fake, as if you could put your hand out and chip the
black paint off the sky. When I saw Zora I thought we were
on a stage together, on the roof of some castle waiting for
Hamlet's ghost to appear. She was leaning over the edge
greedily inhaling a joint and the first thing she said was,
"Do you want to get high?"

"No," I answered, "I only do pot when I feel safe, like
if we were sitting on the BMT heading out to Brooklyn,
then I'd smoke dope. But here in the woods? No, I don't
think so."

"Wow, nature is where you're supposed to get high.
What else don't you do?" What else I didn't do Zora was
majoring in, and after an hour I began to think it might be
easier to discuss the two or three people she hadn't slept
with, if they existed, because it sounded like she had
gloriously gone to bed with the entire school. Funny, her
fucking everyone and my fucking no one seemed to
accomplish the same thing. We were both alone. Zora told
me she danced for days on end in the woods, stopping

only when someone fucked her. She would leave her body and afterwards return to go on dancing. I was very impressed with her.

Below us the students had lit a bonfire and I couldn't tell if they were chanting or killing each other, but the music was easy to understand, and as it floated up we danced to it. Zora was a great dancer. I gave her some of my speed and we danced on the edge of the roof like angels, not in a plastic box but under the giant black sky, while the music grew and the frenzied students stopped dragging the furniture from the main building to the bonfire, and looked up at us open-mouthed, with the wonder of dumb beasts.

Dawn arrived bone cold. Smoke crept over the charred ruins of what could have been a small city while the coyotes trotted back and forth over the lawn as if they owned the place, and the students lay about in the gray light petrified in hideous poses. Ducking down so the dreaded coyotes wouldn't see me, I pressed the heels of my hands deep into my eye sockets; I was coming down. I had to get out of there. The dawn had also transformed Zora from an exotic temple dancer to an emotional suitcase. Her face was frightened, like a child standing on the platform of

a train station waiting to be picked up, her sexy voice
reduced to a thin whine. "You can't really say no to sex
here because it's natural. . . . And sometimes I don't want
to do it 'cause the guys don't bathe and they fart in bed
'cause that's natural too. . . . But if you say you don't want
to, they yell at you or maybe throw you out. I left two
other schools and my parents said if I couldn't stay in this
one, I couldn't go home . . . couldn't ever see them again.
I wish I could travel with you."

She disgusted me, sniveling and weak, all that sex stuff
was just a front, she was a victim. Behind her head, far away
over the treetops, I could see the ocean, where it had been
waiting, hiding behind the night. I could feel its needy
sucking undertow pulling me down with Zora, threatening,
pounding, turning my head to stone.

Quietly I backed away as Zora stared off into the
distance looking for the train that was supposed to come.
Downstairs I picked my way through the living statues.
Only their eyes worked. It was creepy, hundreds of eyes
trapped like birds inside their skull-cages, surrounding me
as I tried to recognize the poor zombie who had driven me
there. When I did find him, he miraculously recovered,
mumbling, "Wow, wasn't that groovy? Can't wait to trip in

43

the desert." Terrified of being stuck there like Zora I told him I couldn't wait to go home, and I meant all the way home to New York.

Back at the Castle that's how most of the Exploding Plastic Inevitables felt. Without New York we were so miserable that when Faison, our roadie, tried to cheer us up by taking us to see Venice Beach, no one would get out of the car; we just sat there looking at the ocean.

Paul Morrissey kept up a running critique. "It's so dirty, all these people have nothing to do. Why don't they fish or something? That's the problem with Californians, they are so happy they don't do anything." Paul had become our hero in L.A. because he could never open his mouth without trashing everything. It was his idea to come here; lots of Andy's ideas were his ideas, and this was one of the worst.

Andy sat resolutely in the backseat. "I'm not getting out of the car. You go ahead. I'm not getting out."

"Let's go back to Ben Frank's and sit there," said Lou tonelessly.

"Yeah," I said, "Let's go to Ben Frank's." The ocean reminded me of Zora's blue pacific eyes and I would much rather stare at Formica and glass.

44

"This is disgusting," Paul continued. "They're all junkies here. It's LSD. It's ruined their sense of humor." That was the other odd thing about Paul, he was anti-drug as well as anti-everything else, but he was right. Venice looked mournful, full of old people at the ends of their lives and junkies at the ends of their ropes, sitting together on benches and staring at the ocean that prevented them from going any farther west. Timothy Leary said this was where civilization would begin its new era; from right here we were supposed to lift off into space, to our true home in the stars, but I didn't think so. It didn't look like a runway that would be used by anything but the wind.

The great Warhol entourage stood at the airport like refugees waiting to be mailed back to New York. No one was happy. No one had become famous. Hollywood had ignored us. We were retreating from California like Napoleon from Russia, in utter defeat. Gerard was dragging boxes of equipment along the airport carpet, tears of frustration in his eyes. Perhaps he was the only one who had had a good time in L.A. and that was why Andy was torturing him now, telling him there was no return ticket for him. Gerard followed us anyway, refusing to be left behind, dragging his boxes of stuff. I went and stood with

45

the boxes. This was fucked, they were being shitty to him—
and, after all, we were a team.

"Gerard, if you can't get back, I'm staying here with
you." Gerard looked at me as if to say, of all the times to
want to stay with him, this was the dumbest. But then he
smiled. I'm not saying the distance between us disappeared,
but it did get smaller.

"Mary, come on. We're going."

"I'm staying with Gerard."

It was the right thing to say. Behind me Andy heard
my father's voice, *you had better bring her home safe and
sound, Mr. Warhol.* To my intense satisfaction, they gave
Gerard his ticket and we boarded the plane.

Seeing the way Andy and the others had tortured
Gerard did not give me a secure feeling. I knew Lou liked
me; at the hard-core gay bars he would refuse to go in
with Andy unless they got me in too, but I couldn't
depend on Lou, he already had two iron mistresses, music
and heroin. As for Andy, I wondered if he really liked
people, or did he just like being fascinated by people? I
didn't feel very fascinating. No, I was definitely alone.
Staring out of the plane window I silently hoped L.A.

46

would fall into the ocean like the prophesies predicted, while we hurried back to the safety of New York. I had to be stronger, much stronger, so I could always fly above the jaws of Zora's miserable fate.

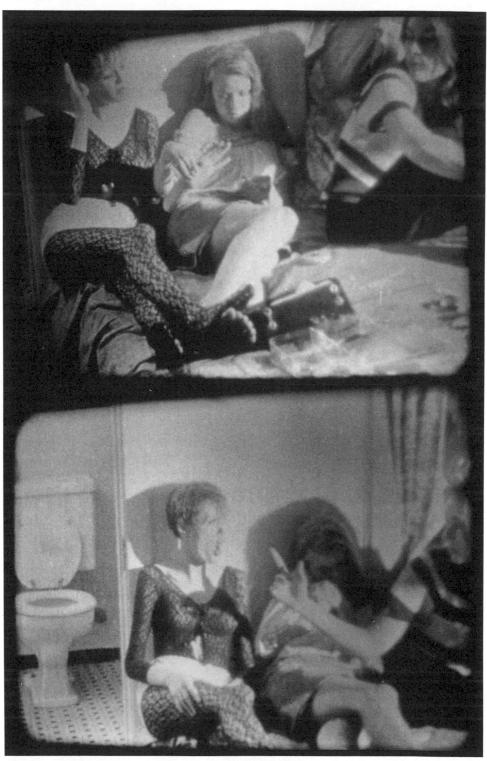

Ingrid, Pepper, and Mary in Chelsea Girls

Chapter 3

CHELSEA GIRLS

was high again, positively stoned to the gills. I arrived early while the sun was still visible in a hemorrhaged sky. There was never any prearranged time; some people came, no one was there, so they left to come back later. While they were gone others showed up, and pissed that no one was there, they left too, to make phone calls. It went on like that until Andy arrived, then everyone crowded into one room at once. The windows were sealed, the doors were shut, and my blood pressure rose two hundred points.

The set was a room in the Chelsea Hotel. It was Velvet's room and Velvet was a slob; a girl slob, messy but sexy like underwear and perfume. Velvet, or International Velvet as Andy called her (like he tried to call me Mary

Might, a name I instinctively fought and refused to answer to, knowing that somehow it was a plot to steal my soul), was a society girl from Boston hoping to follow in Edie Sedgwick's footsteps, footsteps that seemed to lead straight to the rubber room so far as I could see, but that was her problem; I was more than willing to be the first step in putting her there. She was mine, my victim, according to the script which was a very S&M setup, with me in the S part.

I almost started purring as I watched Velvet root through her makeup while trying to re-glue an eyelash the size of a caterpillar. Her skin was alabaster, not yet a mark on it, like a blank canvas waiting for red paint. Her eye makeup, already black, cried out for a touch of swollen blue. I hated makeup, but I loved to watch Velvet pile it on. It was a never-ending job. I lay under my sunglasses on a bed as dirty as Jones Beach, watching Velvet build her incredible sand castle of powder and mascara that I had every intention of kicking in with my new platform boots.

"No matter how much you put on your face," I whispered to her, "it won't make your butt any smaller."

"Thank you, Mary!" she screamed back at me, and continuing in an ear-aching drone, "Andy, you've got to

keep her away from me while I get ready, and Andy, if the phone rings I have to be able to answer it. I'm expecting a call from a modeling agency, it's really important so promise. . . ." Her fancy Boston monotone sped along oblivious to the sign that read Danger Ahead.

I was not listening to her. I had slid from Velvet to Valerie, and I smiled as I remembered the sound of Valerie's bones cracking, the thud of her head hitting the blackboard, that weird bleating noise she made which made me hit her even harder. Valerie was the first girl I beat up. Right in front of Mrs. Eagleson, the geography teacher, who was so shocked she just stood there with her mouth open while I smashed Valerie's arm under the desk top, not once but twice. Valerie didn't know what hit her, but I did. It was this black dog that lived in my stomach growling away until I couldn't stand it anymore and I attacked whatever was in front of me. I gave the dog a name—it was Violet, for violence.

Actually Violet was a house pet. I got her at home when I couldn't stomach breakfast anymore. Every morning Mom ended up hitting my kid brother, Victor, in the head because he wouldn't eat his eggs. His eyes blamed me from across the table (normally I ate his food for him, which is

why he weighed about as much as a bird while I towered
over everyone in my class), but I couldn't eat those eggs.
He would put syrup on them hoping they would turn into
pancakes (he was only seven), then he'd gag, then she'd
scream, then he'd cry, then she'd hit him, then we'd go to
school. It was giving me an ulcer and I was only in eighth
grade. I could feel my stomach grinding up inside me on
the way to school, while Victor trotted along beside me
completely happy—he was like that, he had the attention
span of a mouse. If I turned on him and yelled, "Don't you
remember how you were sobbing twenty minutes ago?"
he'd just look at me in that baffled, hurt way. So I didn't
yell at him, I just ground my teeth and dreamed about how
I was going to beat up Valerie during my lunch break,
smash her head until she looked at me in that same baffled,
hurt way and started crying. Valerie was also my best friend,
which made this daydream particularly satisfying.

Then somehow it happened, the day Mrs. Eagleson
stood still while I beat the living shit out of Valerie.
From the moment Violet leapt out of my stomach I didn't
have an ulcer anymore. Valerie had a black eye instead.
Maybe I loved this dog because Mom used to hit me when
I was Victor's age; maybe Victor was going to get a dog

that lived in his stomach too. One thing I knew for sure was that later on it was going to eat up my insides, make me do terrible things to myself, make me fall in love with someone I hated, and hit my kids 'cause they wouldn't eat their eggs. But now I liked having Violet around and had no intention of putting a leash on her. I'd just have to tell Valerie that I wasn't sorry, it wasn't an accident, and I was going to do it again. I'd tell her about the dog and if she still wanted to be friends, fine, but Violet was coming along too.

To my surprise, Valerie decided to remain my friend after all, not because she was a forgiving person but because she fell in love with Violet. She treated her like she was her own, worried over her, conspired with me to feed her by luring my unsuspecting classmates to the school bathroom where I was supposed to beat them up. The first time it was easy; Valerie brought Barbara Bender with her. She was fat and ugly and I really liked slapping her around. The next time it was Pamela Tarkington—she was one of those little girls that boys really like, the kind that my mother told me not to be jealous of because in ten years her looks would be frumpy and I would be glamorous. I'm not saying I believed her, but I did feel sorry for Pam, she was so pretty, and I really didn't feel like hitting her. In the end I didn't

have to. She started crying right away so I just pushed her under the sink. Feeling cheated, Valerie wanted to increase our performances from once a month to once a week and I panicked. She even had the nerve to threaten to report me if I didn't go along with her.

Sulking in the porcelain caverns of the school john, I was waiting to tell her it was over when she walked into our tiled web dragging Martha Parks, a shy epileptic child whom our callous class treated like a leper. I flipped out. Rage—Violet leapt out of my heart, straight for Valerie's chest. This time Valerie had two cracked ribs and a broken finger, and the thing that really pissed me off was she was happy about it. I had to get rid of her. She was a ghoul, but she was clever; she told her parents that she had been mugged on her way to school. I did the only thing I could. I put Violet down.

I didn't have the heart to actually kill her, but her new cage looked like a coffin buried deep between my liver and stomach. Violet didn't like it but she stayed there until I first started fighting with boys in high school. Then she dug her way out. I slapped Bobby Donavin who punched me right back in the stomach. It hurt so much I couldn't drag Violet out again if I wanted to. She was shell shocked. She

wanted to stay in her cage and just daydream about killing people, which was fine with me.

To tell you the truth, I forgot about Violet until I started making movies with Andy. This time it was the people at the Factory who coaxed the unwanted stray out of my shadow and encouraged her to play in movie after movie. I knew they thought Violet was a budding dominatrix, and although I could have told them she hated sex, I had to admit she was more than a bad temper. The drag queens loved her—she could be so dramatic, and they convinced me that as long as the camera was watching, it would be all right to let Violet run free. I bent down and took off her collar, and as the arresting officer in my first real Warhol movie, *Hedy,* my fingers sank into the frightened flesh of Mario Montez, bending his arm back till it threatened to snap off like the wing of an exotic Puerto Rican bird. His eyes rolled back in fear as his neck, a thick creamy mess of fleshtone pancake and five o'clock shadow, stiffened in excitement. That was enough; I didn't want to overdo it. I put the collar on and sent Violet back down to the kennel under my heart. We were an instant success, and a new role was immediately created for us in Andy's new epic, *Chelsea Girls.*

Velvet was beginning to really annoy me with this telephone shit. She was nervous because she thought this was her big movie chance. What a stupid cunt. Even I knew this was not the way to Hollywood. I was not really sure what this was the way to, other than an odd kind of boredom. No matter how simple they made it—Paul loaded the camera, Andy pointed it, and Gerard started the tape recorder—there were always endless amounts of waiting. Of course there were endless amounts of drugs too, which sort of made up for it. I listened to the three of them talk about a scene that they had already shot with Ondine. Apparently he had decked a girl called Rona and they were laughing about it because the audience reaction had been cheers.

Paul, laughing: "Everyone sided with Ondine, it was really terrible."

Andy: "Oh, it's our best film yet. It's so beautiful."

Gerard: "Rona was being a cunt. Shit, this stupid tape recorder. I hate machines."

Andy: "I don't. I really want to be one. Everything would be so much easier."

Paul: "Gerard, you're going to break it. Let Billy fix it. You know, Ondine can be so nice and then so scary—it's really quite shocking. Everybody in the room was terrified."

Andy: "That's because he's a star."

Paul: "Yeah, but how did he know that we all wanted to hate Rona? How did he know all the audiences sitting in the dark were waiting to hate Rona?"

Gerard: "He should have hit her again."

Billy, exploding out of nowhere: "They're all frightened of his anger, so frightened they never listen to his words. If they did they'd realize he's right. There is no argument, there can't be. He is the Pope. You don't argue with a pope, unless you're nuts, unless you want eternal damnation to hit you." For a moment nobody said anything. Normally Billy never spoke; it was rare that he even left the Factory to help us set up. And now, after fixing the tape recorder, he vanished.

Gerard: "Anyway, it's a lot more interesting than Nico cutting her bangs."

Paul: "How can you say that? Andy, Gerard doesn't like Nico's part."

Andy: "You don't like that? Oh, why? It's so beautiful."

Andy always said the blandest things; it drove people crazy, they were forced to read meaning into his words, but we knew different. Andy was not only dyslexic but he was

uncomfortable with words. Under pressure he was always asking someone to read this review or answer that phone or talk to so and so for him. I think he was seriously relieved when Allen Midgette started impersonating him on the college circuit. He never took vacations or enjoyed himself and was suspicious of anything different. I think the only reason he liked me was because I was Catholic, like everyone around him, and I was Slavic. In other words I was familiar, and therefore to be trusted. But we all liked him, and felt oddly protective towards him, even if it meant protecting him from ourselves.

Ondine was different, filled with opposites—he carried chaos around with him like a pet. People loved him and feared him, calling him both decadent and moral. I found him a lot sexier than the sleepy boys who hung around the Factory waiting for . . . whatever. Actually, if I had to align myself with someone at the Factory in order not to get fucked with, Ondine would be a good choice. I wasn't high society enough for Andy, Paul considered Nico the most beautiful, and Gerard, my one-time protector, was fucking Velvet. (I could tell because her father was a businessman and he was carrying a briefcase instead of his usual whip.) Talent, of course, meant nothing to this crowd. I was the

only one who memorized my lines and no one even noticed.

Ingrid: "Andy, why didn't I get a script?"

Andy: "I don't know, ask Paul."

Paul: "Because you do a great improvisation, but we don't want you to talk in this one."

Ingrid: "Andy, what's my role?"

Velvet: "There are only two roles in this—Mary and me. You're just a presence."

Ingrid: "A presence . . . what's that?"

Gerard. "Something that doesn't talk."

More waiting. It was beginning to get on my nerves. I didn't want anything to go wrong; I didn't want any bizarre twists like the one Valerie turned out to be. What a fuck-up that was. While Velvet slugged out of her vodka bottle, a little too greedily for a girl of good breeding, I quietly clocked the other two girls in the movie; Ingrid Superstar was on pills, but they had no effect, she was naturally nuts, and Pepper was new. Nobody knew what she was on; nobody knew who had brought her either. She didn't look too good around the edges, kind of like a cabbage going bad, the loose cannon for sure. I should have known she was a masochistic plant to bring me out, but I was too busy

preparing my own surprise. These people didn't know that I had spent most of junior high rehearsing for this. Like a heavyweight contender, I couldn't wait to get into the ring. I practiced attitude (fuck you, fuck you, fuck fuckin' you) and I did speed till I thought my head would explode and my heart shriveled to a pinprick.

Finally we were ready to roll. After someone mumbled "Action," things moved quickly; they had to, Andy didn't believe in cuts and the script was just one long interrogation scene with me as Hanoi Hanna and the rest of the girls as GI Joes. Right away Ingrid went manic trying to hog the camera, so Velvet and I spent the first five minutes tying her up and stuffing her under the table. Violet wanted to crack a few of her ribs too, but I said we didn't have time. I was in heaven when the phone rang, and turning to face Velvet, I pulled it out of her reach.

"Mary, let me answer the phone," she said politely.

I just repeated the script but I could feel Violet's saliva on the back of my neck, her breath close to my ear. "Tell me, stupid GI, what was it like sitting under the old oak tree?"

"You promised." Her eyes filled with an odd combo of fear and annoyance.

"Were mother and father under the shaded wisteria tree?" Behind me Violet growled low and heavy, "Tough shit, pig face, come and get it."

"That's my call."

"You don't have a call," I said. "You have a fat ass," Violet chimed in.

"You bitch, give me the phone," Velvet hissed.

Nothing went according to plan. Instead of trying to grab the phone Velvet ran out of the room, making Violet go completely nuts. Like Godzilla, she attacked Velvet's makeup as if it were a miniature replica of Tokyo. I had to pull her back into place. Of course Velvet came back almost immediately, she couldn't walk out on her big movie chance, but it was too late. My attention, along with Andy's camera, was riveted on Pepper, who had taken Velvet's place as victim, and was reading the script back perfectly, like the brain washing rituals in old war movies.

"It's closer to Sodom, Mass."

"What is? Your beautiful house under the shaded elm?"

"Wisteria—"

"Under the shaded wisteria. Your girl is beautiful. Your home is beautiful."

"If you say so—"

"Yes. All your friends in the door are beautiful, waiting there . . . and you are lonely, lonely. . . ." With every question Violet was making a meal of Pepper's ego, ripping it apart like raw meat, and there was nothing that was going to stop her. Pepper tried to rebel by throwing a glass ashtray, which shattered on the rug, but it was too late, her willpower hung like a dead chicken between my teeth.

"Pick it up, Pepper."

"Yes ma'am."

"Use your feet." She took off her shoes and walked around the rug, collecting the glass in her bare feet, a human carpet sweeper, but that wasn't enough for Violet, she wanted humiliation too.

"Why did you throw the glass, Pepper?"

"I don't know."

"Why did you throw the glass?"

"Because I wanted to."

"To show off, that's why." Violet and I grinned, showing off a little ourselves. I wanted to feel like I could open my mouth and fill it with Pepper's flesh, close my teeth on her skin and tear it away, making blood pump like a fountain over everything—rug, clothes, hair, face—both Violet and I stopped in midair. Pepper's eyes had flooded

with tears. It was too easy, she was enjoying this. Her body softened like a sponge waiting to soak up my punches. Her lips smiled the same way Valerie's did. It was as if I had discovered maggots in her flesh. I recoiled from her where she lay on the bed like a piece of rotting meat. Violet put her tail between her legs, while I tried to continue my monologue. "Hello, out there, Mr. and Mrs. America and all the ships in the China Sea. . . ."

When the film was over, the air was seedy and grim as the set of a porno film. I figured the whole thing was a flop since nobody was saying anything. Then I started thinking of the azaleas under Miss Smith's window. The only way I had been able to get Valerie off my back had been to go to my Latin teacher, Miss Smith, and confess. The confession was long and humiliating but Miss Smith was a good choice; she did not try to hug or scold me; no, she didn't even look at me, not even when I started to cry. Gazing instead at the azalea bushes blooming beneath her window, she spoke quietly. "We have always been aware of your violent nature although I didn't realize that it had gone this far. You must stop now. Valerie has chosen her path, she will be transferred. She will not report you and I am not going to either. No one would benefit from such a scandal. But

you must not strike anyone again, and just as importantly you should not let anyone hit you, even if they say they love you. If you cannot do this, other authorities will eventually deal with you. Now, we will never speak of this again, but remember my words and they will protect you from the demons to come." Bewildered, I stared with her at the azaleas rioting under her window.

"But, Miss Smith, what—"

"A simple 'yes ma'am' will do." Miss Smith spoke perfect Latin but when it came to English she had a very proper southern accent.

"Yes ma'am . . . but what about my dog?"

"Your dog?" That made her smile. "Why, I suggest you turn your dog into a hero like Circe did."

I didn't say anything. Perhaps she had lost her mind, or was just too old to remember that Circe was the sorcerer who turned Ulysses' men into animals. But now, sitting here with Violet, I understood what must have really happened. When Ulysses and his men got off that boat after so many months at sea they were already animals; but not realizing how inhuman they had become until they saw the elegant Circe, they blamed her for their appearance. It was only after Circe nursed them back to sanity, a task equivalent to

sorcery, that they became human again. Maybe I should stop thinking so much and sleep a little more.

Violet had curled up next to me, positive I was going to shut her away for good. Instead I gave her a hug. Miss Smith was right, I would make Violet not a hero, but an actress. Then we could still go out together, but only on casting calls. We would do plays together, and who knows, maybe go back to Hollywood where she would support me, have her own union, get her own trailer, and they would have to pay me a fortune just to take Violet out for a walk. Fortunately, Violet was way ahead of me here. She had already captured the heart of Ronald Tavel, the scriptwriter Andy was using, and three days later he called me for a job, the first of many plays Violet and I were to do Off Off Broadway. I kissed Violet right on the head. She was the nicest thing a mom could give her daughter.

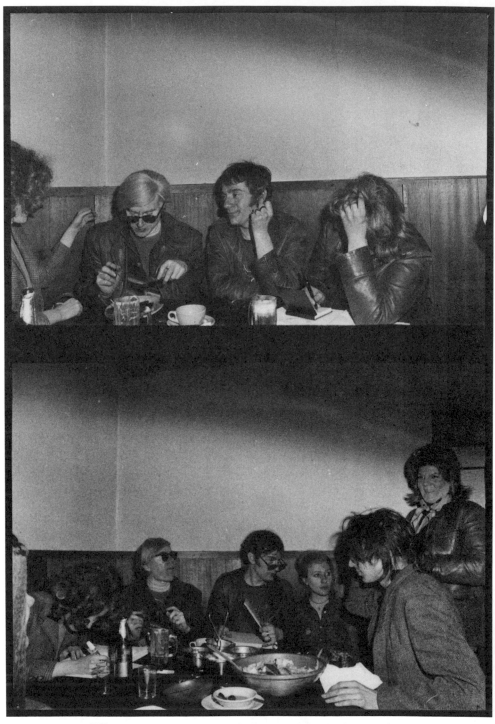

Andy's table, back room at Max's: Viva, Andy, Ondine, unknown, Rene, the Duchess.

Chapter 4

THE
ICE QUEEN

Having rifled through the medicine chest, I began on the bureau drawers in their bedroom. My parents could hide nothing from me, not that they tried. The place was more like a drugstore—the moment I decimated one bottle of Eskatrol they replenished it. Today there was a sale on Ritalin but my rat still felt like complaining. *Why don't they stock black beauties, they look nicer; shit, what about morphine, why can't we ever have any of that?* Whenever I got high my rage rat was with me. He had a diploma in drugology and a radar device for finding the stuff. Right now, we were on reconnaissance, and in my search I came across stuff I would rather not have seen; a picture of Mom when she was beautiful and happy—what happened? *That's what marriage does.* Going through my dad's drawers pissed me off. *Pissed*

us off. There was a love note from Pat. *Who the fuck is Pat?* And his clothes were more expensive than Mom's. *What about your clothes, all you ever got were hand-me-downs.* And he had the bigger closet. *He's such a self-satisfied prick.* And he had the most shoes. *Why don't you fill them with gasoline and set them on fire?* "Shut up, will you?" I must look stupid talking to myself like this. *You are stupid.* "Shut up."

There was only one way to shut my rat up, and that was to be around something even more enraged. At first I thought this was impossible, but then I met my first drag queen. Rat relief at last. Finally someone angrier than I was, and with a sense of humor about the whole thing. I felt calm, tranquil, as if I had found religion, and as long as I was around the queens even my rat assumed table manners, cracked jokes, let other people talk. Pretty soon I was a drag queen junkie. Most of the people at the Factory found it amusing that I'd rather hang with queens than suck up to the stars. Everyone else assumed it was drug-induced insanity, except for Lou Reed—he had the same bad taste for sleazy street scenes and tacky drag queens. When the queens weren't around he would imitate them and make me laugh.

Anyway, this is why, in the dead of winter and the dead of night, I was filling up on drugs and making my way across Greenwich Village to Riker's Coffee Shop to meet

Celinas. I had to get my fix, my Celinas, my beautiful beloved Celinas. I wanted to devour her. She was incredible. She wasn't a floozy like Jackie. No, this was a complete Irish Catholic schoolgirl look: natural red hair, gold cross at the neck, peachy beardless skin, and some of the most restricted manners I had ever seen. She kept her eyes lowered Geisha-style, her pleases and thank yous were soft but articulate, and her wrists and ankles crossed every time she sat, as neatly as if they had been tied; plus she had a great pair of legs. Most queens have great legs, but, alas, Celinas's legs ended up in two very large feet, which were jammed, probably with the aid of a hammer and chisel, into an extra large pair of very proper women's pumps. Large feet were her only telltale flaw. Just the word "shoe" could make her hang her head in hopeless defeat.

I first met Celinas at the Factory. She had come with Brandy Alexander. And if she was shy, Brandy was her opposite, the obvious overdone showgirl-type of queen— stripper tits, bimbo hair, Louise Nevelson eyelashes, and a mouth brought to you by Chevrolet, a red chrome grill motorized on continuous yap. Desperate was too exotic a description for her; let's just say she was bugging everybody that day, waving her airbrushed 8x10s dangerously close to Warhol's nose. The polite light went out, and Brandy

73

became free bait; the tinfoil walls of the Factory flickered like silver water; the smaller surface fish—visitors and squares, scattered and knotted in excitement; and from out of the aluminum depths glided the larger fish—predators, attracted by the commotion. Billy Name, one of the Great Whites, appeared and disappeared. Often his presence signaled the difference between light play and heavy hardcore shit.

Gerard was the first to attack. Something about where did she put it? Come on, show us. I listened to Brandy's little squeals; first the giddy surge of finally getting the attention she had been bleating for, then the sickening realization that it was too much, it was going to hurt. Gerard was relentless, goading, taunting, and jabbing his prey. "Come on, Brandy, we know you tuck. Tuck it up. We wanna see. Where does your dick go, huh, Brandy, huh?" Shouts. Cries. Drag queens are unpredictable to wrestle, sometimes a good right hook can be sleeping under all that makeup. Most of us were only watching, hopeful that Gerard might get slugged in the face, but I was watching Celinas. She stood like Anne Frank in a Gestapo lineup. Good choice. I liked it.

I didn't know what she wanted, or why she had come with Brandy, but I did know the last thing she ever expected

to get was me. I slid in close to her, mesmerized by the panicked rabbit jumping up and down in her jugular. Maybe you should sit down, here on this silver couch that, by the way, is just as dirty as the gutter. When she sat, she crossed her hands and ankles perfectly. Yes, yes, everything was in the classroom. We chatted, bonded, as Brandy flopped around on the silver concrete floor with the silver hook still in her bloody mouth. Both of us were excited. Celinas tried to climb into her purse, which was filled with dirty broken makeup, the true sign of a queen. I was thrilled she had let me look, even slip my hand into it for a moment. I let her huddle near me, but when she tried to clutch my hand I had to recoil. I hated being touched by anything in the human-skin package.

Now in Riker's Coffee Shop's depression atmosphere, threading my way through the Puerto Rican killer queens, I closed in on my fabulous Celinas. At first she was nervous and catty to me. I countered by discussing sneakers and threatening to go into open-toe heels. Soon we were chatting like lost sisters. Her mother hadn't seen her since she left home as a boy, and she wanted to send her an 8x10 glossy so mom could realize what a nice proper-looking girl her little boy had turned into, not ratty like some of those sorry TVs. I told her it was a great idea and imagined this

poor old lady having a heart attack by her mailbox somewhere in Kansas.

People were staring, I could tell by the way Celinas was arching her neck, as if there was a gale-force wind blowing and she was the only one who could feel it, her own constant hurricane. I liked that. People always stared at me, too.

Actually, I didn't know how to describe myself, but this is what Louie Walden said to me one drunken night: "You are a beautiful girl, beautiful, but you don't act very attractive, you know, and it scares people. Yeah. I mean, you don't act cute like a girl, you act like a guy. You know, people ask me all the time if you're a guy in drag, and I laugh at them. But you are very powerful. I mean, we know you're a kinda shy, really nice girl from Cornell, right. I even know you're a virgin 'cause I can tell. But when most people see you, oh, they just assume you're mean, mean as a snake."

Maybe he was just trying to get into my pants, but I don't think so. Louie was a hetero actor, meaning he was busy laying everything in sight, but he was just as comfortable flirting with the queens in the back room of Max's Kansas City as he was in a macho fist fight in Max's front room. So far as I could see he liked his drugs in either

room, which was his plus. His minus was that he liked them too much, that's why he was getting high with us instead of on Broadway. As for the virginity crack, I had to correct Mr. Walden here: It was true I didn't fuck, but as we know I was not a virgin. This was precisely why I had taken it upon myself to get fucked by that anonymous busboy, so that people like Louie couldn't have these smug assumptions concerning my sexual status. This kind of thing really upset me. Another minor correction was that I might have been beautiful, but I was also six-feet tall, flat chested, and foul mouthed, not to mention extremely rude to anything I was attracted to. That I lusted after the rock 'n' rollers that hung out on our fringes, in the bars, and in the arms of other women was my darkest secret. To my horror I could see pieces of my busboy in these guys; you know, the way they tilted their neck or how their arm lay across the back of a chair. My favorite smell was still Canoe and gasoline, which made me think of cheap white skin on inky black nights. The painful part was that these guys did not like me in the least.

My way of dealing with this problem was simple. If I couldn't have them the next best thing would be to be them, as if being was a form of possession. (This was amphetamine logic at its clearest.) I started imitating guys in

the same extreme fashion that the queens used to imitate women; I held doors open for women, talked about tits and ass with men, and told everyone I owned a gun. Needless to say, guys hated me but the queens applauded. That's the thing I loved about drag queens, life was a constant movie; no matter how ridiculously things didn't match they would sacrifice everything for the pose, and I was definitely into the pose.

Celinas and I made quite a striking couple, her with imaginary tits and me with imaginary balls. I was really hamming it up. I had just finished telling Celinas how I had robbed a couple of White Castles, a total lie, I wouldn't even eat in a White Castle much less hold one up, and she was telling me about her black boyfriend and how he beat her up all the time.

"Perfect," I murmured, "what every white girl needs."

"He brings home the worst trash. Of course, I don't have real sex anymore."

"Yeah, me either."

"I'm too busy being a woman. It's a twenty-four hour job."

"I'm too busy getting high. Imagine if being a woman only took thirteen hours."

"What?"

"Nothing."

"I mean, I don't go around asking people for a Tampax, like some people I know" (she meant Candy Darling), "and I'm not a tramp" (she meant Jackie Curtis). "I don't want to be a star" (she meant everyone; she was lying. I loved her).

"Will you go to Max's with me?"

"That art bar? I can't. I'll get arrested. You don't know. It's a crime to be a TV."

"I know."

"I could get arrested, or get the shit kicked out of me."

"Please."

"No."

"It's a different kind of bar. I know people there. The whole back room is gay, you'll be protected. Come on. Please." I had a plan. Celinas was going to help me do something I'd always wanted to do—fuck someone, in the heart. Humiliate them, and I would be the only one who knew.

I got her all the way to the door of Max's and she wouldn't go in. "Please, Celinas." I broke my code of not touching and pulled her into my body so maybe she would feel my determination. Her head flopped back, eyes closed,

mouth parted. Queens were like that, so wired if you just touched them they would go off into a torrid movie affair. "Yes, baby, I want to kiss you, but not here. Let's go inside, please," I crooned, rocking her on my hips, "Trust me."

"Okay." Her head flopped forward again, "Okay." Just like a lamb to the slaughter. I laughed. I loved this. "Celinas, you're gonna have a ball, I promise you. No one will hurt you, baby." Fear was making her very attractive.

I opened the door and shoved her in. "Stay close to me," she pleaded. Close to her! Fat chance. The minute she was in, they fell on her, every jerk in the room, especially the Italian studs, the ones with wives and girlfriends tucked away in virgin hell, while they rooted around the gutters looking for something trashy, just a little tastier; and the intellectual but totally blind macho artists looking in the same gutter for soul, something their white middle-class families couldn't give them. They lined the long smoky bar of the front room like a gauntlet we had to pass. If you were cool you never looked at them on your way to the back room, but this time I couldn't help staring. All the men who were so put off by me melted before Celinas, and as we passed by each one turned to us in a Rockette line of mating stances. I was impressed. And Celinas, she blossomed, from a shy iris to a gobbling orchid. She was

80

starved for romance, to be kissed and flirted with, instead of getting her head shoved below the nearest belt buckle. As they broke from the bar and started grabbing at her she became petrified she'd been discovered, but her fear only turned them on even more. It was a match made in hell. I looked up to see a particularly classless dude slide his tongue into Celinas's mouth. That called for time out, I owed her that much, so I went over and tapped her on the shoulder. "Let's go to the ladies' room. Dick-breath can wash his teeth without you."

Celinas's mouth dropped open, and I jerked her to her feet and threw her in the can. Everyone cleared out at the sight of us, so we had the mirrors to ourselves. Far too classy to use anything like red, Celinas started putting on a simple neutral lipstick, but soon she was picking at the hickey on her neck. As for me, I didn't wear lipstick, so I tried to see if there was enough speed left in my nostrils to get me high again.

"That's cute, Celinas. Jesus, what's he got, a fuckin' vacuum cleaner in his mouth? You're gonna get beat tonight, baby."

"Oh, well, it'll look good with a black eye. What are you doing?"

"What do you think I'm doing with my fuckin' hand

up my nostril? Looking for rocks, checking my donuts, I don't know."

"You're gonna get a nosebleed."

"Yeah, I should get a nose to bleed through first. Fuck this, I should just get higher. Let's go to the back room."

"Let's go back where we were."

"You mean back to pencil-dick and the eraser-heads?"

"What do you mean, pencil-dick?" She sounded genuinely worried.

"That's what Roda, the black-haired waitress says his problem is. But then she's got her own problems; she's balled so many of her customers she can't tell which dick goes with which face."

"Do you think he suspects that I'm—"

"Suspects? That's too difficult. He's still working on wonder. Look, Celinas, don't worry. They are the freaks here, not you."

"Yeah?"

"Yeah. You should just have fun. You know, there's this dark Italian-looking guy you should meet. He loves redheads. He's real sexy. . . ."

Yes, I thought he was really sexy. I couldn't help it. He knew it too, it was pathetic. Every time I was in the same room I couldn't stop looking at him, so I had to avoid him.

I hated being attracted to him—it was like a stone around my neck. I remember the first time I had that kind of experience; it was on a car ride on Long Island. I was fourteen and the guy was maybe sixteen. There were six of us kids in one car and we were so tightly crammed together that I couldn't help touching him, but I secretly enjoyed it. At every turn I let my body sway into his, thinking he wouldn't notice, but he busted me in a loud voice. "Tell your dopey girlfriend here to stop pushing her smelly old body into mine, she's makin' me sick." In other words, I learned that when I felt that intoxicated way, it usually meant the feeling was not mutual.

"Italian, huh?" crooned Celinas, "They're so dark. I just love dark guys, the blacker the better."

I grinned. "I told you I'd kiss you tonight." Her eyes crossed in confusion. "You didn't expect me to do the kissing, did you?" I continued, "Jesus. That's too twisted. Let's go see who's in the back room. Get your purse."

"Where is *your* purse?"

I looked at her, deadpan. I never carried a purse. "Between my legs, Celinas, come on."

I dragged her into the infamous back room. Warhol was holding court. When he saw us he whispered to his minister, Gerard, who immediately started screaming for

us to sit with them, which was a joke because there was no room; besides, I didn't come when Gerard called anymore. Ondine was at another booth, so I quickly shoved Celinas in there. Having Celinas with me I felt brave enough to sit at Ondine's table. He was already speaking to about three people at once, so I hoped he wouldn't mind a fourth. I could see Warhol's group made Celinas uncomfortable. Little did she know the real anaconda was Ondine.

Watching Ondine I felt my face flush; he was incredibly handsome to me. His profile looked like it should have been on the back of a Roman coin, but instead it was surrounded by ruin: restless black hair and clothes that were ill fitting, borrowed, and thrown on a body that looked powerful but off balance. His mouth was long and acrobatic, sneering and smiling simultaneously. So far I had only watched him from afar because, like everyone else, I found him intimidating, but now as his eyes looked at me I did not squirm as I had imagined, instead I felt released. I could detect no revulsion or hate as his eyes opened my darkest corners in a matter of seconds. Then his attention returned to the crowd around him. While he spoke he changed their gaze into utter discomfort by putting a dinner napkin over his head like a kerchief. It made him look foolish and matronly. But no

matter how humiliating he looked, it was his audience that felt embarrassed, and he seemed to enjoy this. I started to laugh, and he laughed too. Celinas and the others shifted in their seats, but his voice prevented anyone from leaving; it was like a tempest coming at you from all sides.

"Those dogs out there—sniffing each other's assholes. Oh please, the idea is even boring, darling, sniffing assholes is boring, and if you don't know that I can't help you. Then by all means tell them to come in here, hah, they wouldn't dare. Celinas, dear, how are you? Ah, you're mute, what an attribute. You'll have to forgive me, I'm being mummified. Yes, mummified, by this—all this, and her. She makes me sick. No, I don't mean you, you poor warped boil. Who could ever forget you—oh, if only I was humiliated, if only you could humiliate me, what a divine experience, but not by you, you're boring, boring, my dear yes, you heard me—I want an ambush, to be ambushed, but they don't understand. Who can blame them? I don't even understand."

I might as well have put a leash around Celinas's neck and tied it to the table leg. Ondine's tongue had nailed her to her seat, her eyes floated in confusion just as I saw Louie Walden walk in. I slipped away and cornered him. "Hey Louie, is your friend Dominic out there?"

Louie smiled. "Yeah, I came here with him, but you know he won't come in the back room. He's too macho, can't handle so many queers." Louie rolled his eyes. "Who's the redhead?"

"It's a guy, Louie. I'm surprised you couldn't tell."

"Well, she's really good."

"That's nice, 'cause she really wants to meet your friend, Dominic."

"That's evil, Mary."

"I know, I want you to introduce them."

"Wow. Okay, but it's going to kill Dominic if he finds out."

"Yes, I know."

I stepped into the front room to watch. As Celinas and Dominic gravitated towards each other like a pair of magnets, I didn't think it was evil. I liked both of them. It was annoying. If they were together they could cancel each other out, their magnetic pull would stop fucking with my compass, and I could sail away before I drowned in their indifference. I hated being left out. I watched his hands touch her as he talked, kidding, playing, fingering her, then slowly holding her, kissing her on the mouth, and letting her take his tongue like a little dick. I watched her back arch and his eyes grin. Their ocean sloshed around in my skull,

my shipwrecked thoughts drowning, trying to clutch onto pieces of brain tissue that swept by. And then it happened—the swirling stopped and the ocean froze as I realized Dominic was kissing his worst fear—a guy. He didn't even know it and he was doing it in public. I started to laugh, my arteries crackled like frozen tundra, snow silenced the aching, and miles of Arctic ice separated me from all emotion. I loved it. Time to get high, man, real high. I walked into the back room as if it was Valhalla with Louie preceding me, telling everyone that Dominic was kissing a TV. Ondine shrieked when he saw me. He sat down beside me, and I could feel his full attention on me, and with it the attention of everyone else. "Mary, you're fabulous, you frighten me so much. I just love it, darling. And where did you find the lovely Celinas? Nobody has brought me something like that in centuries."

I smiled. "They don't call me the Ice Queen for nothing."

My rat had left the door to the back of my brain open and through it I could feel the sun glittering on the snow. He would be back, but right now he was gone. Peace. Celinas was sucking away in the front room, Ondine was laughing in the back, and I had never been so happy.

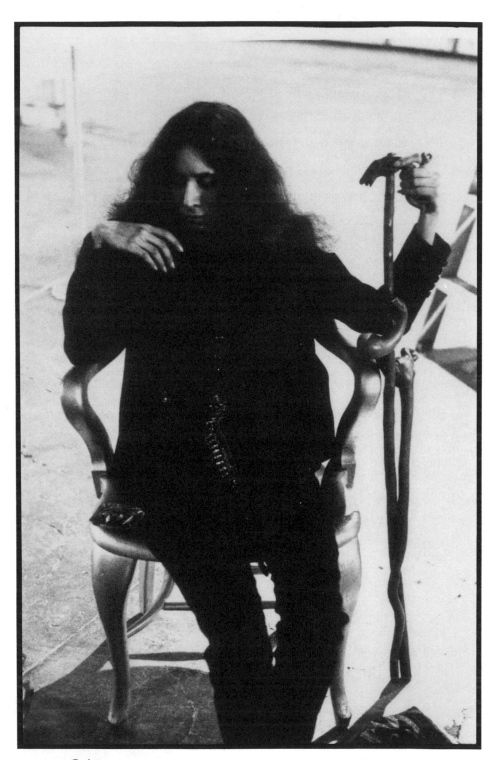

Orion

Chapter 5

THE
MOLE
PEOPLE

ndine was like The Cyclone—he thrilled and terrified me even though I knew I was in an amusement park. Rooms grew old when he left and after talking to him I couldn't bear normal conversation. I started going places to be around him, the gayest bars, the most bizarre parties. I was fearless, and it was only a matter of time before I was introduced into an extremely narrow circle that surrounded Warhol during the days of the Silver Factory on 47th Street: the Mole People. Mole because they were only seen at night wearing sunglasses and a skin pallor that had to be the result of years of subterranean existence; Mole because they were known to be tunneling towards some greater insanity that no one but this inner circle was aware of. Some of the Great White Moles were Ondine, the Pope; Rotten Rita, the dealer;

Orion, the witch; the Duchess, and of course, Billy Name, the protector of the Factory. The Moles even dared to rename Warhol "Drella," a combination of Dracula and Cinderella, which became his pet name. Drella warned me to steer clear of the Mole People, so I kept my distance until one night Ronnie invited me to get high with them. Ronnie was a rather handsome straight-looking but totally speed-crazed homosexual whose last name was Vile in case anyone was fooled by his pleasant manner. He said that for the last five days the Moles had been cooped up in an uptown apartment making necklaces, and all I could think of was that they must have some really powerful dope to keep that bunch stringing beads for a week. But the real reason I got in the cab with Ronnie was because he said Ondine would be there.

As we rode uptown, Ronnie began telling me how he was forced to screw this woman for money, and she was making him live in the broom closet. I hated knowing this shit and couldn't care less. I was coming down, and I was worried about my teeth falling out of my head. I didn't know why, I just thought they were planning on leaving me. It was only through superhuman jaw clenching that I was able to listen to Ronnie, until he started blabbing about the Mole People and then my ears pointed straight up. He told

me really weird shit about how Moles who were weak were thrown out of the pack and left to die by sunlight. I'd already heard of Moles caught by the dawn patrol, trying frantically to climb under anything—cars, trash, a piece of rotten newspaper that they had to chase down the street—as the daylight singed their fur. Ronnie was cracking up, talking too much, paranoid that his brother Moles were planning on tossing him into the sunlight. I thought of tossing him out of the cab, but it was his cab, and I had nowhere to go, which he seemed to understand, taking me under his bony wing. His breath smelled vile.

We cut across the black underbelly of the Manhattan animal, and wherever we cut, its colorful guts tumbled out: hippies, hustlers, hookers, heroin users, they trickled into the streets collecting in pools at the corners waiting to be pumped through the veins of the city. When we stumbled onto the sidewalk I had no idea where we were. I don't even think we paid the driver, he was so happy to get rid of us. My teeth were banging on my gums—we want out, we hate you. Traitors, I thought, as I sealed the door of my mouth shut. God in hell, just get me inside and I'll be okay. As he pulled me into an expensive brownstone I wondered if Ronnie could hear my teeth yelling.

Inside, all the queens and queers were in one room. It

93

was painted gold, and it was vibrating, humming like a great nest of wasps. Beads of every description were all over the floor, in different-sized containers on the tables, and hanging on the walls in every kind of necklace imaginable. The electric lights were blaring, forcing the occupants of the room to wear sunglasses that only added to their insect-like appearance. Each bug held a big fat needle, and you knew they were shooting up; but every time you looked at them, they pretended to string beads, with smiles that fooled nobody. Rotten Rita grinned, and a rotten tooth fell out of his head. Without missing a beat, he strung it onto his necklace. Orion was wearing jeweled chicken bones about her throat. She also had glued her hand to the arm of a chair and with a smile, she removed it like a glove.

I always had trouble dealing with Orion; she was too witch-like for my taste, and as we already know, my taste was pretty squirrelly at this point. Even Ondine hated her suicide altar, where she surrounded Jesus with pictures of famous suicides and anonymous kamikaze pilots. Ondine hated black magic and death worship, but he loved Orion. As a matter of fact, if he ever did have sex with a girl, he would have chosen her and some say he did. She carried a long black staff and a dark sense of power, and I had to admit she was beautiful and strange.

94

Rumor was, if you believed in those things, that she was a black witch, which would explain the feathers. There were always feathers around her—on the floor, broken ones in a chair she just left, little white ones on her chin, ugly yellow ones from some unfortunate chicken whose last job happened to be a voodoo ceremony. I don't know, maybe some part of her body was constantly molting. She even smelled of burning feathers, a smell associated with angel dust. When she was high, black feathers fell from her fingers like the shadows of stilettos. Ondine said one time she was so mad that all the feathers collected in the middle of the floor and turned into a big black crow that attacked him.

Now, as she watched me, her eyes went warm because she was gay or because she was just hungry, it could be either. It was common knowledge that she never fucked except for money. Even then she spent most of her time in costume and very little on her back, yet she was paid a fortune, a lot of which she gave to friends. Orion was the first one to do really kinky sexual shit like making the guy masturbate all alone and then jumping out of the closet yelling, scaring him to death just before he came. But her true audience for these fabulous performances was Ondine, whom she often invited to watch from the same closet. It

was all too confusing for me, and I carefully avoided her. As for Ondine, my heart sank when I looked around the room and saw he wasn't there; but it was too late to leave so I wedged myself in between two madly humming hornets and started stringing beads.

"Don't go near the windows," they hummed, laying out two giant lines of white powder that I greedily snorted.

"Beware of the windows, darling," they smiled, laying out two more big fat lines. I couldn't believe my luck.

"No, no, don't touch those windows," they snickered as the drug took hold and stringing beads became my life.

Oh yes, the bead stringing was absolutely fierce, with the necklaces growing in size. Yes, yes, this was a very competitive group—who could make the biggest collar. The buzzing increased, the weak dropped back, pushed into corners where they were relegated to gathering and sorting stray beads. I heard them talking about me out of the corner of my ear.

"Look at Mary."

"Aww, how sweet. Is she praying or counting?"

"Or is she just pretending?"

"I don't think she really knows, know what I mean?"

They were after me, but I just kept stringing. It didn't matter anyway. I wasn't even thinking of them—what I was

worried about were my teeth. What happens to them when they come out? Is there much blood? I mean, blood shooting from the empty sockets in my gums, or will they simply drop out with a little dust? I've had dreams about this, where my teeth were loose and I spent all night holding them in place.

I hadn't said anything for four hours, afraid to unclench my jaw. The race to string the biggest necklace intensified. Silverware, records, anything was pounced on and incorporated into the decorative noose we were all weaving for our group suicide. Along with squeals of humming and droning, huge beads were rolled across the floor. Shiny gelatinous encrusted goo hung from the walls in various lengths. None of the bugs could stand the mounting pressure; they started banging into the walls and apologizing to themselves until Ronnie made a breakthrough into genius. He stood up with his arms outstretched—for a moment I thought he was going to fly—and then taking one, then two steps, he fell on his knees before the couch and began stitching his neck to it. Immediately all the bugs had a degree in eighteenth-century surgery and they ran to help him. Needles flashed. Ronnie begged them to sew really tight, he didn't want to fall off the ultimate necklace. The last moans that slid out of his mouth were familiar to me; I

had heard them backing up in his throat all during the cab ride over here.

I put my antennae back in my ponytail. I knew I wasn't in the habit of seeing someone attached to the couch by his vocal chords, but these insects didn't seem phased by it. Suddenly Ondine's voice made my heart leap. He entered from the back room looking like Sir Laurence Olivier playing Caesar in Bedlam, and taking one look at Ronnie he put a scarf over his head and announced that he would be receiving confessions in the back room into which he disappeared. Just as I was feeling sad that he had left, an incongruously fat amphetamine lover called the Duchess snuggled up to me and suggested I follow her to the back. We had met before and liked each other immediately. As I got up to leave, the hornets beside me buzzed furiously at her, "She doesn't talk, you know. She's mute, leave her here. Don't go, *n'approchez pas les fenêtres*. Don't go near the windows, Mary." It was true, by now I had given up all hope of talking, my face was molded shut from the nose down, the girl in the iron mask. No one seemed very upset by this; instead they seemed to enjoy reading my thoughts.

When the door to the back room opened I stepped into the dressing room of insanity. Ondine was cloaked in a brocade drape ripped from the wall, Rita sat enthroned in a

shower curtain, only Billy was not in costume. Necklaces freshly made from the front room were constantly carried in. It was a frenzy of adjustments, rearranging and preening, not just of themselves but of every part of the room. The wrong move for the most innocent reason could result in a shrieking vitriolic attack by everyone. The fact that Ronnie lay in the other room crucified to a green couch added to the tension, and then there was the disturbing number of secret messages being passed by car and paper, one of which was delivered in a black box that no one could open, all concerning whether Jimmy Smith should be electrocuted.

As far as I could figure out, everyone liked Jimmy Smith, who was a nice guy, until his addiction forced him into cat burglary. Still a nice guy, he only robbed his friends, politely warning them beforehand. Once forewarned there was nothing you could do to stop him, so dedicated was he at his trade. Actually it wasn't that bad, he only took bizarre things and sometimes left more valuable objects in return, but Oscar, whose home I was told we were in, couldn't stand it. Nobody could stand Oscar either, he kept his stash in a bank vault so he wouldn't do too much, and conveniently never had enough for anybody else. So while we waited for "the man" like tortured lovers, Oscar waited for Chase Manhattan to open. Much to our satisfaction,

Jimmy started robbing Oscar regularly and leaving us alone. It drove Oscar wild. Nothing stopped Jimmy—cops, locks, bars, none of it helped. Jimmy triumphed every time, but tonight success seemed impossible; Oscar had warned us that he had electrified the gates on the windows. He even found Jimmy and begged him not to do it, but Jimmy only handed him a note saying tonight was the night.

"That's it, Oscar, you must turn off the electricity."

"No, no Ondine, Jimmy must stop robbing me. I have a right—"

"Stop whining, you vermin. Only a lunatic would try to rob this place now."

"Yes, and he will die," Orion cut in. "That's why Ronnie is tied to that couch by his throat, because we are not supposed to stop him."

"Orion please, as the Pope, I command you to stop speaking of his death. He is not dead and he will not die." Ondine's eyes flashed in anger but Orion's eyes blazed right back at him.

"He is already dead. There is nothing you can do."

"It's a curse, a curse, a curse . . . she's cursed me, cursed me. . . ." Oscar backed away from Orion and fell to his knees, banging his head on the floor.

"Somebody put something in his mouth, shut him up."

"No, let's read the *I Ching*, I need it for my headache."

"Then Orion must be banished. She cheated last time. She can make the coins move around, I've seen her do it."

"You can't banish me, I'm going myself and I'm warning you now, you had better dress for the event at hand."

It was too medieval for me, plus it took forever because whatever they said was constantly interrupted for the adjustment of their wardrobe. I left and stumbled into another room where Lou and several other mad scientists were having an even more heated debate involving experiments, diagrams, and human guinea pigs over the various merits of two different kinds of speed. Sneaking away, I crawled back to the outer nest where my two insect companions greeted me. "Didn't we tell you? Those windows are the killers." They handed me a needle and some beads that were all in the shape of teeth. "We found them for you. We thought you would be back." Mutely I gave myself up to the companionship of my two friendly hornets and the contentment of stringing milky glass and ancient blue beads together.

The room glided peacefully into calm waters with its cargo of pilgrims and saints. Occasionally a Kafkaesque

paranoia would surface out of the glittering black water, the feeling that my body was becoming bug-like, but concentrating on necklace-building submerged it. The minutes rolled back and forth under the glaring chandelier. We were becalmed. I watched the couch drift on the floor with Ronnie lashed to it. Blood trickled down his neck, reminding me of the first blood I ever saw on my thigh. . . .

My parents were aware that I was not turning out right. Notes from school—Mary is too violent, not ladylike, too big, too strong, not aware of others, the list was endless. It was true. I was very big and strong for my age, and for a moment there I was afraid they were going to stop feeding me. Things got tense at the table, and looking upset they would mumble, "Don't eat so fast," until in desperation they took me to the dentist. If it were up to them they would have bought a full body brace or at least a cage for my head, but being cheap all they got were braces for my poor wild teeth. The same day the braces went on I got my period—nature's first iron link in the shackles of mortality. I was humiliated and furious.

My brother, only six at the time, sensed my pain and thought it was being caused by the iron contraptions in my mouth. He worried in my shadow, baffled by my parents' inhumanity and unsure as to how long I could take such

102

torture. My poor little brother; he was convinced the sun rose and set on me. Secretly in the playroom I pounced on him and poured my angry heart into his fragile pink ear. All the women in our family, I told him, had to have our teeth bound, otherwise they would gobble things until they gobbled up the world. Remember Grandma's false teeth when she came to visit? Well, her real ones had to be pulled out, and even the false ones had to be removed at night and drowned in a glass of water. And Mom's beautiful teeth? Caps. Her real ones were small and pointed like a shark's and could reduce bone to powder in a second. Our father didn't have polio—she had ripped up Daddy's leg so bad that he would have to limp for the rest of his life. If I were to loosen these rubber bands in my mouth, I would start eating uncontrollably. First, I told him, I would consume his foot while he was screaming, then his leg, then his stomach and fingers, and I would not be able to help myself—my teeth would have their own voracious agenda. Victor believed me. All I had to do was put my fingers near my mouth, and he would go into paroxysms of half laughter, half real fear, and run from me screaming. Of course, I gave him a demonstration that would have put me in Bellevue had anybody else been watching.

I stopped drifting. What was it? I had seen something.

Everything was still, just the dry bead stringing noises, the scraping needles, the insects were happy; then I saw it again—Ronnie's hair moved, fluttered. The wind was picking up, I could smell it, cold yet burning like the dust of angels. The floor rippled and swelled, we were moving again—then the room jerked violently as if we had hit something, tilting the floor so all the beads rolled with our eyes to the kitchen door, which flew open. Emerging from the kitchen Orion filled the doorway, threatening to capsize everything.

Hideous and beautiful with her black hair curled into snakes and all her feathers alarmingly red, she had dressed for the occasion and beyond. She was wearing the floor, a linoleum dress in the Cretan style, which exposed her breasts and fell in heavy shingles to the floor. Having been banished to the kitchen cave, an unused room with a single pot of solidified wax and human hair stuck on the stove, she had managed to skin the harmless floor of its linoleum and make her costume. The ugly red rooster feathers escaping from the cracks in her dress were blood. She had glued pieces of the linoleum to her skin, which I could hear ripping under her dress as she walked towards us. She said only three words: "Jimmy is dead."

Ondine came from the back room, his curtains

blowing in what looked like a hurricane. "Someone has opened a window," the insects hummed in my ear. "They must have turned off the electricity," I said. I couldn't believe it, I had spoken, the curse was lifted. "Turned off the electricity?" the bugs hummed, "I'm sure no one's thought of that."

The final crash was terrible, you could tell it was something human sliding off the building and dropping into the alley, and we all knew what it was. There were awful popping noises while Jimmy was stuck to the gate, but worst of all was the smell of charred flesh. I had never seen anyone die before, but this was the first time any of us had to smell a guy die. Now Jimmy was nothing but a smoldering bundle of rags, hardly visible. Ondine roared as if he had been hit and went for Orion, to make her take back those awful words, but she had already escaped out the front door. We ran to the window to watch her stagger and fall in the middle of the street, pinned by the weight of her dress to the double yellow line. She looked back up at us and smiled. From her point of view we must have looked like an incredible collection of moths pressed under the glass of the window as we watched her flutter hopelessly. The sun calmly opened the sky like a pale rose. Soon the "Good morning, I'm going to work" centipede

would be upon her, devouring her. Her skin would melt under the thousand stares and she would be pathetic, but for now she was beautiful.

I know Ondine felt bad. He was the only one who had not gone to the window to watch her. The Duchess, on the other hand, remained at the window well past dawn with a dildo slid down her pants. She insisted the mailman was queer and could be enticed. And Ronnie, of course, couldn't stop shaking everyone's hand, thanking them and telling them how good he felt after his ordeal. I found Ondine in the bathroom, his noble hawk head buried in his hands. "Are you all right?" I asked him.

"Yes." But he did not look up.

I had never imagined Ondine could be hurt. I wanted to shield him, which was ludicrous because there was nothing he wouldn't do in the area of drugs or perversion. He didn't really have limits, but now he was wounded, an unhappy Aeneas slumped on the edge of the tub, brocade mantle pulled about him, with only the ruins of Carthage left smoldering in the dawn. It threw me into agony. I couldn't leave him, but I didn't know what to do.

"Do you want me to stay?" I fumbled. What a stupid question. "I mean, do you want anything?"

Without looking up he took my hand and pressed my

wrist against his forehead, "No, but when you come back, I'll be here. I'm going to stay for a while. I have a degree in alchemy that I'm working on. You are coming back?"

I had to whisper so he couldn't hear my heart pound, "Yes." What I didn't tell him was that I didn't care where Orion went as long as she never came back and I could take her place in his heart.

"Then good night, darling."

"I have to go home." I did. I needed rest.

"I know."

"But will you wait for me?" I didn't know what I was saying. "Or should I just go and come back?" He looked up and started laughing very softly like a cat purring, his eyes wicked and happy. Everything was all right again.

Lou wanted me to split a cab with him. He was going to Dr. Feelgood's for an extra potent B_{12} shot. I said no, there was only one way to go to Brooklyn; take the black subway under the river of forgetfulness. However, this time it did not work; I forgot nothing, and when I was home I didn't belong. I had changed. There were no outward signs, but I knew it. It was no longer them, it was us. Their rules were mine, their insanity my reality, and as for the rest of the world, it just didn't matter. I was a Mole.

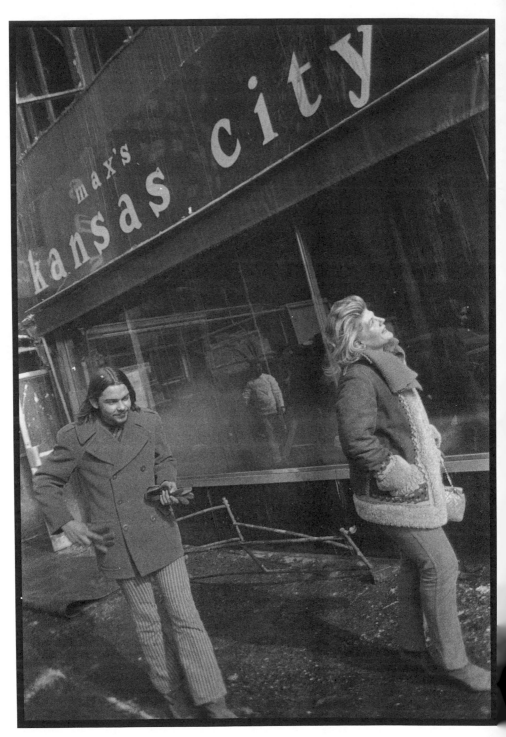

The Duchess outside of Max's

Chapter 6

SHOW TIME

fter sleeping thirty-six hours I stumbled into the kitchen and, falling on my knees, I thrust my head and upper body into the refrigerator. It was a joke in my family how much I could eat, a joke that still made everyone uncomfortable. This time I planned on breaking my record. Cleaning out a plastic bowl of macaroni and cheese, I discovered some week-old turkey behind a green jello mold. Coming down off speed, flavor was not important. I could eat ice cream on top of herring, or the green stuff on the edge of leftovers. Amount—that was what was important. I was trying to decide if I should eat through the jello mold to the turkey or cannibalize the turkey immediately and decimate the mold on the way back, when my mother broke my concentration.

"Mary, we're about to have dinner."

"So?" I looked up at her through the dull film that had permanently settled over my eyes. She had to know how I felt when I was down like this, why was she torturing me? Suddenly the film lifted. Next to her elbow, glowing on the counter, was a white Ebinger's bakery box. I don't know how I missed it. Catapulting from the refrigerator to the countertop I ripped open the box and sank my fingers into the dark chocolate icing.

"No, Mary! Mary, no! That's for dinner."

At the table I stared at my plate. I had no idea what I looked like, I hadn't seen my face or combed my hair in days. I couldn't believe my parents didn't know I was on drugs, but I was a good liar, a talent I got from Mom. She was the master fabricator of happy endings for our childhood stories, which were dragged out at family gatherings to be picked over and caressed by everyone at the table. Mom could lie about anything. Worried by my poor dating efforts, she had recently changed her sermon on the pitfalls of sex to a tiresome monologue on the blissful orgasm, an overnight metamorphosis I didn't believe for an instant. Since boarding school I had been storing my supreme little pleasures like rotten eggs so I

would not have to share them with boys, and I wasn't about to start now.

I held my head in my hands so it wouldn't roll off into someone's plate as Mom and Dad joked about how they had to hide dessert from me because I once ate a whole cake and got sick. It never happened. I could easily eat two and a half cakes, that was what was really scaring them.

"It didn't happen," I growled belligerently. "That never happened."

My little brother's eyes darkened with hate. "Yes, it did too."

"I don't even want your damn cake, I just want to get out of here." This is when I was always told to leave the table. *Hey, fuck your cake. How 'bout that?* My rat screamed at them from inside my head.

In the bathroom I looked down at my belly pregnant with food. How could I have gained so much weight in three hours? I pulled on my now skintight black leather pants while our ancient pet beagle watched me from under the sink where he lived. "No one wants to pet you anymore," I hissed making him turn to the wall. I was just fucking everything up, even for the dog. Mom thought the problem was my not having a job. It was beyond me how a

woman could be so misguided. Couldn't she see that I was a great actress, that I was working on a new method of acting that involved incredible improvisations along with mammoth doses of speed? Why, just last week I met Tennessee Williams at the Factory, and although he was too drunk to know who I was, I knew who he was. Instead she had reduced me to reading the want ads for my breakfast, and pretending to go on interviews, while in fact all I ever did was march up the street to a girlfriend's, have a second breakfast to calm down, and crawl into her bed after she and her husband went to work. This had been going on for months until one day her husband came home with a strange woman and wanted to use his own bed. But that was the least of my problems. How was I going to find the Mole People again? I felt terrible; I had told Ondine I would return three days ago, but I was so wasted I couldn't get out of bed. On the other hand, if I stayed at home any longer I was going to end up like our dog, living under a sink next to a radiator, dreaming of trees. I had to find Ondine. Opening the front door, I was planning to sneak out but my father walked up behind me. Shit, he was going to tell me to hand over my key and not come back. Quietly I grabbed the doorknob with both hands, while my

toes started curling in my shoes looking for something to hook onto.

"Honey, there's some cake on the table for you."

"Oh . . . no thanks, Daddy, I gotta run."

The Factory was dark. It took me a moment to figure out what was going on, and when I did I knew Ondine wasn't there. Andy was torturing several people, several rich people judging by the little gleam of jewelry at everyone's throat and wrist, and by the smell; the rich have a certain smell when they are upset, like good food going bad. I saw little screams for help shine in the ladies' eyes, and heard the soft groans from their husbands as they twisted in their chairs. Oblivious, Andy calmly loaded another reel of his twenty-four hour movie called *Fuck*. He knew they were unhappy, but he always thought if he just showed them a little more they would finally understand or maybe even like it. Tonight he was projecting two separate scenes and soundtracks onto the same screen at the same time. The result was excruciating; the very air was turning black with pressure as the bright flickers of pain shot through it. To make matters worse, one of the uncomfortable women sat very near a famous art critic who was watching this mess with a cigar in his mouth and an anonymous dick in each of

his hands, the owners of which lay stoned on either side of
him on the silver couch. I was happy to see the rich had to
go to hell too, and I would have stayed to enjoy their
discomfort but I was more interested in finding Ondine. I
told Andy I had to run.

The only Mole I knew, and who I thought might help
me, was the Duchess. During *Chelsea Girls* Andy had
gleefully introduced her as a vicious lesbian (they were best
friends), but I recognized her type immediately from
boarding school—she was the fat girl who loved to torture
other girls, and I got along with her great. I had done well
at boarding school; you couldn't call it sex at that age, but I
had tortured my share and been tortured back. The Duchess
was as fearless as she was fat. She shoplifted in only the best
stores with the composure of a right-wing Republican and
shot up in the finest restaurants, slamming the spike through
her jeans, through her skin, and into her system as casually as
if she were fixing her lipstick after dinner. Her greatest talent,
however, was gossip; every drawer and shelf of her little
room in the Washington Hotel was filled with tapes of
conversations and Polaroids. I didn't understand where she
kept her clothes, or her sanity for that matter.

"Ondine? Who knows, he's probably in Queens with

his mother. You know, parents. My parents won't give me a dime anymore, but Father just went senile and now has to beg the help for money. They have been warned not to give him any more than twenty cents, so sometimes I give him eighty just to fuck things up, or maybe two dollars, but all in quarters. Did you go to the Factory?"

"Yes, will Ondine st—"

"What was Andy doing?"

"Showing that film *Fuck* to a bunch of stiffs."

"That means he's going to be upset because nobody liked it and we won't be able to get our manicures tomorrow. I'm not answering my phone then, that will get him. You know Andy calls me every morning first thing. Do you want to hear a tape of yesterday's conversation?"

"No."

"Do you like that title, *Fuck*? I told him to call it *Twenty-Four Hours*, it's much nicer. Don't you think Nico is stupid, I mean besides being German? And Ultra, I don't believe her act for a minute."

"Have you seen any of the Moles lately?"

"I haven't seen Rita, have you seen Rita? If you see him tell him to call me, it's really important, I have to see him. You know he once pulled a gun on Andy, to play

Russian roulette, and only Ondine stopped him, everybody
else was too scared. Usually Ondine never stops Rita, they
are very tight. Actually no one stops Rita, it's not a good
idea. Do you think Ultra is a hooker or does she really have
money? And Ultra Violet, where did she get that name, she
must be covering up something."

On and on she went like a dentist with a drill, I
couldn't stop her. My mind started to sweat and run out of
my ears. I felt as bad as when my dad stuck those giant
needles up my nose to drain my sinuses because I was
snoring so loudly. Finally, with my hands stuffed into my
ears, I told the Duchess I had to run downtown.

Max's Kansas City was the only place to go at that
hour and it was packed as usual. In the front room I let a
dealer I knew from Cornell put something in my mouth. In
the back room I saw Ondine. I stood there . . . and I stood
there, but Ondine didn't seem to recognize me and I was
too shy to go over uninvited. As I continued to stand there,
panic set in; there was no place for me to sit, and nobody
was calling me over. I had gotten stuck in the doorway
where all the nobodies hesitated. Just as I was about to save
face by ducking into the ladies' room, Lou Reed grabbed
my hand and pulled me over to his table.

Right away he started talking about his favorite subject, the Korean healers who operate with their hands, pulling malignant tumors and black stones out of their grinning patients. He was obsessed and had collected tons of pamphlets and magazines on the stuff. I tried to keep up with his enthusiasm and not think about Ondine's ignoring me. I pretended I hadn't seen him either when Andy called over in his high voice, "Mary, you should have stayed. Everyone said they really liked the new movie."

"Great," I yelled back. He sounded really happy, it was sad. I wasn't going to tell him what I thought the critic had really liked, besides I didn't know if it was the drug the dealer had given me or hearing about Lou's Korean healers, but out of the corner of my eye I saw a hand pass through the skin of a girl's stomach. People were smiling as they secretly fingered each other's insides, then someone handed me a heart which was still beating, just as Eric sprawled across our table. "It's so crowded, mind if I lie here for a second?"

"Be my guest. How come it's so crowded?"

"That director is here with his big Hollywood actress." I looked around the room. They were easy to spot, they were the only two people eating. No one ever ordered

dinner at Max's, we were always too high to eat unless someone else was buying. Twisting his body around, Eric continued to purr, "And they'll probably try to drag me or Andrea or both of us up to their hotel room again tonight."

"Jesus, Eric, you fuck everything."

"I'll fuck you if you like."

I let that pass. "So what are they like?"

"He never gets hard, just sits with his back to the wall and his big soft dick in his hand, and she likes pussy. Want to try it?"

"So what do you get out of it?"

"I like pussy too. I like having famous Hollywood stars travel all the way to Max's so I can fuck them when I feel like it." Eric was impossible, I didn't know why I bothered talking to him; he was too high on his own body to make any sense. Like a big golden-haired cat he got up and jumped to another table.

"Show time!" someone yelled.

"Not this again." Lou left.

"Champagne! It's show time!" Rene started screaming. For some reason my legs weren't working, so holding onto the table, I prepared to do the Warhol watch as Andrea Whips climbed onto her table and the show began. Singing

"Everything's Coming Up Roses," Andrea partially stripped and partially jerked off. It was okay, we'd seen it before.

The red neon sculpture that decorated the room made the whole event look like it was taking place inside a rotisserie; maybe that was where Rene got the idea that Andrea should rotate on a spit. Anyway, uncorking the champagne bottle, he got her to put it up there. I didn't want to believe my eyes, the neck of the bottle disappeared into Miss Whip's most private parts as she held it in both her hands, calling for the director and his actress to join her like they did last night.

The L.A. couple did not finish their steaks, instead they exited courtroom-style with their hands over their faces. Everyone cheered. I cheered. It was sort of fun except that Andrea was crazy, well, only slightly crazy; she was at the point where she could only talk to people's reflections in the little hand mirror she carried around. What we didn't know was that she would soon throw herself out of a window, leaving behind only a love note to Andy. She was the second in our group to defenestrate themselves. Freddie was the first, a frustrated ballerina; he had been high for so long he asked death to dance out a twelfth-story window. Andrea had landed on her feet but that didn't help; from the waist

121

down she was hamburger meat, while the rest of her was strangely unmarked.

When I finally left Max's it was four in the morning and there was no lower level to sink to.

Outside, the dealer from Cornell grabbed my arm. "Are you okay?"

"Did you give me acid?"

"No, it's a new pill from France, Quaalude."

We started walking and he showed me where he lived, a gloomy brownstone just a block from Max's, but I didn't want to go in. "Okay, so look, let me take you home."

"No, I gotta run."

"Come on, I'll take you in a cab." He was the dealer for a completely different crowd, a bunch of artists I didn't know, but he was a good dancer, so I let him take me back to Brooklyn. My parents' white brick apartment building rose into the sky like an Aztec altar, the top of which ran with the blood of family sacrifice. Since I hadn't been able to run away from it perhaps I could desecrate it. In the elevator I pushed roof instead of eight. It was deserted except for a few lounge chairs left over from the last ceremony performed by some vanished tribe. Across the river, Manhattan was my mute audience.

My dealer seemed to know what his role was. Dragging over a lounge chair, he took off his clothes and laid them carefully over it. Then he put me down on top of them and pulled off my leather pants. I did not help him.

"What kind of a drug is a Quaalude, a sex drug?"

"A muscle relaxer and some other stuff too."

"What if I don't want to fuck?"

"Then I'll stop."

"No . . . just stop talking."

"Is that all?"

"Yes."

My mother came up all smiles with big glasses of lemonade and my brother pulled a paper airplane behind him while my father tried to get a suntan and listen to the Dodgers on the radio. Their side of the roof was a hot summer day, mine was fallen night. When it happened it was so simple; while I lay in his pale arms floating again on that black ocean, the chain finally broke, and I watched the sunny summer island where my family played get smaller and smaller in the distance.

We slept as the sun climbed into the sky to keep us warm, or only half slept, he felt too good to sleep through. When we emerged from our cocoon of coats and clothing,

my blood did feel cleaner. We laughed and hopped around on the roof getting dressed, but out of habit I must have put on the same old anger along with the rest of my clothes because by the time I finished dressing no metamorphosis had taken place, at least none that I could see. Mom had lied about the blissful orgasm changing my life. I could feel her down on the eighth floor starting to make breakfast, and I got so mad I not only wanted to go back to hell, I wanted to rent a room there, at least until I found Ondine. "You have to go. My parents are downstairs." I could see him wince at the thought. "I don't want to see you again."

"Don't worry, I won't blow your cover."

"You mean people who think I'm a guy?"

"Nobody thinks you're a guy. I mean that you like sex."

"I never said I didn't like sex, it's you I don't want, and you seem to come with the package."

"Come on. Don't be that way. That's all, I just come with the package?"

"Yes."

"If you change your mind you know where I live."

I didn't say anything.

"Can we still dance together?"

I still didn't speak.

"Okay, will you kiss me good-bye?"

"Yes."

"I thought so," he smiled, pulling me to him.

I watched him catch a cab before I left the roof. If I had had a stone I would have thrown it at him.

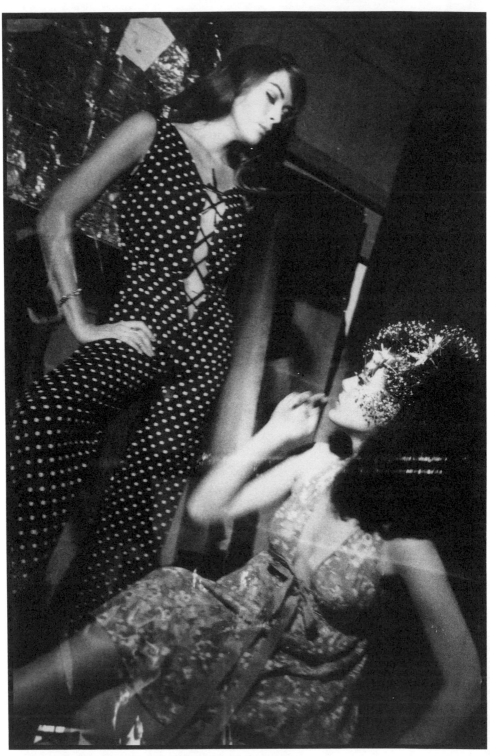

Mary and Velvet modeling at the Factory

Chapter 7

THE
POPE

inally I escaped from my childhood
prison in Brooklyn. Cornell busted my
old roommate Jane, and I convinced
her to come live with me. I even found an apartment for us
on St. Mark's Place just a block from the Dom. I felt like a
kid in a candy store as we set up housekeeping together.

"What's this, Jane? Are you throwing this out? It's
brand new."

"Price tag and all, just came today. Mother thought I
needed something for dating in the big city."

"You do, you do, very smart mother you have. How
did she know I would love it? Neiman Marcus, very middle
class of her, but I don't mind."

"Try it on, but it's gonna be way too short."

"Don't worry, when I want something, it fits." I

contorted my body into the dress and bolted for the mirror. "The shorter the better when you've got legs like mine." I did a couple of half model poses, half dance steps. "Oh yes, this baby fits me fine."

"Mary, that's a size six. It doesn't fit you at all. You look like a mountain lion in a canary suit."

"You're just prejudiced 'cause it's your dress. Mirrors don't lie. It's a department store trick, making a person believe they can only wear one size." It wasn't so much the dress, I really liked changing people's minds, especially Jane's, and she liked it too.

She smiled, "I don't know if I approve of big tall girls in little small friends' clothes."

"This time I'm right. Okay Plain Jane, what else do you have in there?" I headed straight for the closet.

"No, my clothes. Mine. Mine." Jane was pretending fear. We played this game all the time. She would act weak and defenseless and I would be forceful and demanding. When we went to bars together this was our ruse with men. Jane would flirt and act helpless, then I would come in for the kill, and in the end she docilely went home with me. On the way home we would laugh and cackle about how mean we were and how inseparable we were.

130

"Come on, let me try all your clothes on. It's a whole new image for me, the sexy little girl look."

"You look like a Las Vegas hooker."

"Even better. You've got to let me have them, even if it's just for a second." Of course there was no question that Jane wouldn't do it. When one of us wanted something desperately, the other would have to give in; it was a rule we had.

"Costumes are so much better than clothes. They're like drugs, they change your personality," I smirked. "Come on Jane, live a little, put on my boots and things."

Jane lugged one of my boots into the middle of the room and sat on the floor to put it on, while I raced around getting my good black shirt, my shades, and my armbands. Then, putting on the other boot, Jane shuffled over to the mirror with me. When we were through she looked like a midget hoodlum. Even though her hands went automatically to her hips and she thrust her pelvis forward and her legs apart in a very good imitation of me, she was not intimidating. I didn't understand it; after all, Alan Ladd was short.

"Hold your cigarette differently, like this, like you're going to flick it in someone's face."

"No, forget it. You're an actress, a good actress, you can carry it off. I don't need a big flashy look to be a painter. Here, take the dress, it'll be another costume in your repertoire."

Grinning, I put Jane's dress back in her closet. Jane completely understood what I needed when I ranted and raved and jumped around with all my theories and accusations. What I needed to hear were those two words—good actress—then I could relax, daydream to Smokey Robinson singing "The Tracks of My Tears" over and over, and eat scrambled eggs and toast while we read the *New York Times* and discussed our up-and-coming careers in painting and acting—I hadn't decided which one I would be famous in yet.

My little scene of domestic bliss was shattered by the familiar Mom voice. "Mary, come down and help me with these boxes. Your father can't find a parking place." Jane ran to the window but I didn't bother, I knew the green Cadillac and the mink coat were down there.

"Brace yourself, you're going to meet my mother."

"I hope she likes me." Jane was sounding very unsure of herself.

"It doesn't matter, your parents probably hate me."

"How did you know?"

Kitchen equipment. Mom brought boxes and boxes of
kitchen equipment, things like apple corers and jello molds,
and detailed recipes for the simplest things: meatloaf,
oatmeal, omelet, all in the hope that I would give up my
habit of eating like a stray dog. Well, at least Jane seemed
impressed, which was good because so far I didn't have the
first and last month's rent. Poor Mom was all gooey-eyed
about my first apartment and about how I was an adult—
right Mom, an adult mole—RODENT BORN OF NORMAL WHITE
WOMAN IN MINK COAT!

"Of course, now Mary's really going to have to start
looking for a job because she has rent to pay, doesn't she,
Jane?"

Jesus Christ, I almost leveled with her, told her that I
had a job, a very important job, that I was a Mole, but I
didn't want to scare Jane. Besides, someone had obviously
forgotten to tell the Moles I was one of them; it wasn't like
I was getting any invitations to any more Mole parties.
They seemed to have disappeared down some mysterious
tunnel, Ondine with them. Still, with every room I entered,

the first thing I did was check to see if he had resurfaced yet. But at least I had gotten out of Brooklyn, at least I was nearer to what was happening.

Meanwhile, Andy had started sounding like my mother. "Mary, why don't you model? Nico, National Velvet, Ivy, they all model." Andy thought if people didn't work they were broken, something was wrong with them. "Why can't you model too, we'll take photos of you and you'll be famous," he nagged. Nobody could whine like Andy, he invented it. Anyway, all I ever saw Ivy do was take a dump behind the silver couch. This crazy woman wanted to marry Andy Warhol, which meant getting as close to him as she could or leaving a piece of herself with him. She definitely did not have all her oars in the water; if you asked me she didn't even know what an oar was. Sometimes Gerard would have to fend her off, or Billy would be called to throw her out of the Factory. Later the elevator would return empty except for a single lonely turd, and someone would snicker, "Andy, Ivy's back." Yeah, if she could model, I should be getting the Oscar any day now.

Andy, however, insisted, and with the photos that he and Billy took I got into the Ford Modeling Agency. They

must have been hiring everybody that day. No one seemed to notice that I didn't have real skin, that it was actually very sleek mole fur, that I never took off my sunglasses, that my jaw moved constantly, and that while other models went out on jobs, I went out to cop, which was exactly what I was doing when I met Maria Callas.

Wonton answered the door and I knew right away he was macho-Italian, not Chinese. It was his open shirt, and the way his crucifix trembled on its rug of chest hair like a victim in a rape scene. Like Louie Walden, Wonton was one of the few straight people who felt comfortable getting high with the Mole People. However, he didn't look very comfortable now. He immediately started apologizing to me, saying that I had interrupted him and his girlfriend, Marbles, but it was okay, he didn't even want to fuck her actually, but it was the only way he could shut her up, you see. I told him I completely understood and asked where the can was so I could count out the pills I was trading for crystal meth in private. Pointing down the hall, he backed away saying he would be in the kitchen. I could not understand why he was so fidgety, and I had already locked the bathroom door before I saw her—well, part of her. Her head was on the floor jammed between the toilet and the

wall, and her legs were sliding about trying to get a footing on a floor wet with sweat or whatever. I helped her up, helped her rearrange her clothing, and when I asked her how she was, she said "fine," as if we were at a coffee shop, and continued chatting about how she should either stay in bed or get the bathroom carpeted, while she rearranged the makeup on her face as if it was a bunch of flowers in a vase. Mid-sentence I split for the kitchen.

Wonton was not alone. Seated across the table from him in the shadows was Ondine wrapped in an old navy cape. My starved little eyes locked onto him, fearful he might dissolve. When he saw me he stood up, filling the tiny room, and hugged me so that for a second both past and future vanished; we were alone together inside the dark-blue folds of his cape. "And where is the fabulous Celinas? Ah, you don't know? In Kansas, my dear, her mother had a heart attack beside her mailbox and she had to go back for the funeral. Sit down, I'm so happy to see you. The wonderful Mr. Wonton is throwing us a party, aren't you?"

Wonton sat squirming in his chair, digging his hands deeply into his balding scalp. "Yeah, yeah, have some, it's free," his voice cracked, as Ondine patted his shoulder.

136

"Don't mind me. Take as much as you want. No! Yes, I have more. Please."

Nobody had to ask me twice. While Wonton punched himself in the chest I inhaled as much as I could in one snort. The little hairs on my backbone started to dance, but something was wrong. No one was talking. I'd never heard of getting high and not talking. I started to speak—but Ondine raised his finger to his lips, and pulling his cape about him like a blanket he watched Wonton. The silence was like a giant white egg. From the bathroom, cracks started appearing in its quiet shell as the egg gave birth to Marbles's incredible voice, seeping through the walls, beating like a blind parakeet in the air ducts, and finally creeping on its belly down the hallway towards our kitchen. Ondine's smile was luxurious. "Wonton, is that not the fabulous Marbles? You know, my dear, for me she has nowhere near the greatness of Maria Callas, a diva beyond divas, but she does have a certain insanity in her larynx that I am quite fond of, and I am so happy that you appreciate it, too. That is why you are applauding, isn't it? And have I mentioned that this crystal is the finest, and perhaps we should make a record of Miss Marbles in detailed. . . ."

Wonton was not applauding, as Ondine had chosen to

call it, he was slapping himself across the face, stuffing the edge of the tablecloth into his ears, and carving earplugs out of cheese, but nothing could silence those pretty red lips, or stop the little pink tongue from lashing him into a frenzy. Finally, unbuckling his pants, he ran to the bathroom roaring like a bull. Ondine smiled as if he had just baked a cake. "Young love, my dear, isn't it fabulous?"

I thought of the girl I had just seen, her head wedged between the toilet and the floor staring at the crucifix swaying above her like Poe's pendulum, and I regretted we hadn't taken the time to carpet the bathroom. "Ondine, can we get even higher?"

"Yes, I could get you higher. Have you ever heard Maria Callas sing *Tosca*? So high your blood would explode and splatter your brains all over your cranium—excruciating, you'd love it. But Wonton doesn't have a record player, instead he has the fabulous Miss Marbles, the siren of despair."

"Ondine, I have an apartment on St. Mark's. I have a record player."

Ondine pulled three worn albums to his chest and in a voice that was deathly serious said, "If you do this for me you will be saving my life."

138

That night Ondine introduced Jane and me to Maria
Callas, and I realized that Ondine was capable of
regenerating himself just by hearing her voice. Some arias
were so powerful he went beyond himself and formed
wings. Wrapped in his torn cloak and looking like a great
jet that could never get off the ground, he flew around the
room while I tried to follow by jumping off our table till
my ribs were bruised from the continual crash-landings.

Jane was our audience, wide-eyed at first, but as the
hours crawled into days she stared more and more at the
floor. Sometimes people came over to see Ondine, and I
would look across the room at Jane talking politely to a
gigantic queen as if she were her Aunt Thelma. I should
have rescued her, but we were so busy accomplishing
things; Ondine knitted opposites into a lovely scarf, and I
composed my first rigid speed concerto in logic, which I
will now play for you: Order = Fear of Death; Chaos =
True Reality. We took drugs to battle the cages of order, in
order to embrace the chaos of the divine order. I = Order
+ Ondine = Chaos ~ Andy = the black primal creative
negative. I had reduced the essence to the symbol, and
now all I had to do was design the symbol and we could
escape.

By the third day we were so exhausted that Ondine ended up in the bathtub trying to suck his own dick and I lay on my back with my neck on the bathroom threshold using the door frame as my imaginary guillotine (there comes a time when everyone needs their own guillotine). When I asked Ondine why he didn't just get someone else to blow him, he practically had a fit. "You think this is about getting off? Getting off what? The planet? It's impossible, I've tried! I am the last Oboroborus left in captivity. Perhaps I should introduce myself, the snake that swallows its own tail. This, my dear, is about resurrection, not sex. And if this were about sex, I don't think I would be asking you. Everyone has forgotten the origin of the bathtub—baptism. I'm being born, you fool, now close the door."

"He's pregnant," Jane whispered, "Ondine, can I get you some pickles and ice cream?"

"At last, someone who understands. Thank you Jane, that would be wonderful. Now, close the door, darling, I want to see Mary's head roll."

As soon as the door shut, Jane's eyes started darting around as she whispered, "Do you think pregnancy is a communicable disease?"

I looked at her and saw she was really worried. I wondered if I should be worried. My parents had always told me, when "it" happens, come to us, we'll fix "it," but I didn't trust them for a moment. Who knew what foul contraption they would install when they finally got in there; anti-drug devices would be put up like smoke detectors, my poor abandoned sexual canal would suddenly have a mini-Boulder Dam across it, with coils and Dalcon Shields curled like barbed wire along the top, its walls slicked in spermacide and graffiti saying "Sperm go home." At the slightest touch of my abdominal region, thousands of diaphragms and intrauterine devices would snap open like an auditorium of folding chairs and I would simply explode before my lover's eyes.

Jane didn't look good at all and I started to believe maybe she was pregnant and not telling me. Everything was getting so complicated. I started thinking I had to save her, and since abortions were illegal, I'd have to get her a real hospital D and C.

"Jane, listen, first we have to get a bag of pig's blood, they sell them. Don't ask me where. We'll find out."

Jane stared at me, her eyes like pinwheels now. "Mary, I'm exhausted. I'm going to throw up."

"Morning sickness. Jane, listen to me, this is going to work. We'll get dressed up real lady-like and go uptown to a toy store like FAO Schwarz. There we walk around like we're buying, but you trip on a toy car that I've dropped in the aisle. You fall down, cutting open the blood baggy that we've tied under your dress and you start screaming 'My baby, my baby!'"

"Mary, you're not listening to me. I said I'm sick, not pregnant, I feel sick."

"You don't have to be pregnant. Listen to this plan, it's perfect. I rush to your side grabbing the empty baggy and stuffing it into my coat. There will be blood everywhere, it'll be very dramatic."

"It'll be insurance fraud."

"Then there'll be this scene where I tell the manager I saw you slip, and they have to take you to the hospital for a proper D and C. It's not fraud, it's our right to a legal abortion."

"Mary, shut up. I can't stand you like this."

"They'll probably give us a thousand dollars so we don't sue them."

"You and Ondine both have to go. I have to be alone."

"Huh?"

"I have to be alone."

Alone. . . . The word sank into my head like a rock. Give up my little niche in the steel and glass cliffs of Manhattan, fly back to Brooklyn every night in the freezing rain? "Jane, give me half an hour, I'll fix everything."

"I'm sorry, you've changed into someone else. I can't talk to you."

"I thought you were having a good time."

"I can't live this way, weird people going in and out that I don't even know and have to talk to."

"I didn't know you were just being polite."

"You stomping around with your boots at all hours turning everything electrical on, Ondine living in our bathtub, that music blaring away." Jane's eyes finally overflowed with tears, setting off fireworks of guilt inside me. She tried to be brave; she even got upset with herself, saying, "Please, don't tell Ondine. He's wonderful but I can't take it, I'm just too normal." The back of my throat suddenly cramped and my own eyes started to burn.

"Okay Jane, calm down. I'll fix it, I'll fix it. Everything will be back the way it was, you'll see. Just you

and me and the kitchen utensils. We'll even make curtains like you wanted." Actually I needed about twelve hours of sleep, but I'd just have to fit that in later. Jane was asking me to tell Ondine to leave, and I knew I was going to have to do it for her. I couldn't believe my shitty luck. I had just found him and now I had to tell him to go, but I had no intention of giving him up. I would simply split myself between them, living her way during the day, and my way with Ondine at night.

When I explained all this to Ondine he peeled himself off the ceiling and immediately became a gentleman about the whole thing, saying he understood perfectly: Jane was not Mole material, many things should probably be concealed from her, and he did not mind being one of them. Besides, he had to see his boyfriend, Roger, who had a temper and a steel plate in his head. "Good-bye darling," he smiled. "I'll see you tonight."

After Jane crashed in her bed, which I made fresh for her, I snuck into the bathroom to look for the change in me Jane had been so repelled by. I now realized how important it was to me that Jane shouldn't be harmed by me or my fellow Moles, and that we stay friends. I

somehow thought that if I kept my image with Jane intact, I could walk into the land of the shadows unharmed. Everyone makes mistakes.

Binghampton Birdie, Ondine, Rotten Rita

Chapter 8

THE ASCENSION OF SAINT ANN

y nights were spent with Ondine and our good friends, the Moles, and these nights always began the same way— with drugs. This time we were crammed in a tiny apartment that none of us owned. One by one we began to disappear quietly into the bathroom for purposes of chemical alteration. I definitely wanted to shorten the hem on my brain, maybe make a jumpsuit out of the whole thing. Ondine, master seamstress that he was, leaned into the mirror before me and shot up right in his eyeball. I almost puked into the sink.

Murmurs fluttered, the word was passed, "Shot up in his eye," and we all took it as an omen that a particularly intense high was ahead of us—all except Andy. He was

oblivious, buzzing along on his own little yellow pills. He liked to be next to things, feel the energy, but he didn't want to know what was really going on, and we were very discreet. Yes, to the normal eye it looked as if everybody simply had an extreme bowel disease, but to us a bathroom became a temple of porcelain and tile, the inner sanctum of bodily functions where only the initiated were allowed, where the dealer held communion, and ritual held sway.

The door of whatever bathroom we happened to be using was always guarded by some kind of animal-type human, usually a psychopath of the lowest order. The only thing left rattling around in his brain was the pure urge to open your chest and shit on your lungs. Milling around the door and under his control, empty ghosts huddled like shrunken heads. We called them the gray people, unfortunates who had lost their souls to get high. All they wanted was to be the one closest to the door, but one twitch from the animal and they scattered along the ground like wingless birds, scuttling into the corners of the room where they tried to look like furniture so no one would throw them out. We had no sympathy for them. To regain their human form all they had to do was leave, the one

thing they could not do. Instead they hovered, searching our eyes for the flicker of recognition that would turn them from ghosts into people again.

Before I was ushered into the bathroom, I was surprised to see Ann among the gray people, a new little ghost crouched up against the wall like a folding chair. She had not lasted long. When I first met her she was George's girlfriend, but now Silver George in his silver-painted cowboy boots was screamingly gay, and Ann didn't know how to gracefully go back to Alabama. Instead she became a drainage ditch into which George poured his frustrations, and George was very frustrated. The abuse was terrible. None of us liked to watch it, so George usually made her wait in the street. She was such a sad little dish of water; now her eyes followed me vacantly, asking me to tell her what to do, who she was. It gave me the creeps.

Meanwhile, George was on crib duty, meaning he sat with Andy pretending none of this was going on. They were playing Andy's favorite game, "Let's be eleven-year-old girls at a pajama party"—two demented men swinging their legs over the edge of the bed, giggling and murmuring over private jokes, and coloring little drawings

with a brand new pen and pencil set. Actually, this was not so peculiar; we all had these pen and pencil sets and a trip book to go with them, standard paraphernalia for any speed freak against the paranoia that plagued us. Aware that the rap of a speed freak had been known to completely dissolve even the polish off silverware, we confined these rants to our books. Some people thought of their trip books as art—they weren't. They were reams of useless energy, complete with dizzying diagrams of intricate nothing—except when Andy Warhol happened to be doing the drawing.

That night Andy was drawing noses, before and after nose jobs. When he asked me if I liked it, I didn't answer. Why bother? I knew that the stupid drawing would appear in its silkscreen mode later, worth a fortune. My nose would get out of joint when I thought of my own angry black and white drawings. Why were they so unloved? Because Mom left me alone in Macy's department store? It was only for thirty minutes. Who knows, maybe it wasn't long enough, maybe it should have been three hours in order to form the correct aberrant psyche for a really famous artist. Maybe Macy's was really this big oven and she took me out too soon, and that was why I was only a

half-baked artist. When I started thinking like this, I knew I was getting really high and I shouldn't be alone, which is why I was standing in this bathroom watching Ondine shoot up in his eye.

By the time we came out of the john, things had changed. Someone had put on *Tosca,* the Te Deum where Scarpia sings his dream of evil to a Catholic Mass. Even a rock 'n' roll head like myself could sense the oncoming doom. Warhol had left, and in his place sat Rotten Rita, the very king of fear, the altar of evil, our cup bearer. Already he had changed George from an eleven-year-old girl to a six-foot-three reptile hissing venomously at Ann. Eyes averted, hands wrapped around the leg of a table, she crouched on the ground before the cobra swaying above her. "Leave. Do you hear?" His face slid around in cold coils. "Get out, you stupid bitch! Get out while you can still walk."

Actually, I was thinking of leaving myself. Normally I didn't get high with Rita around. I'd take my shit and go somewhere else, somewhere less tense. He was too scary for me, but Ondine had only to look at me and I chose to stay.

Rotten Rita was known to have the worst speed in

New York City. It could kill you. Rita himself was in the
process of killing his own father. Every week they had coffee
together, which Rita laced with megadoses of speed that
often left the old man mumbling ninety-miles an hour to a
light bulb for the rest of the day. Of course, Rita insisted he
only did it to test each new batch of stuff. He was pleased
to announce that this week his dad had tossed himself out
the second-story window and broken both his legs, and this
was the stuff that did it—all of which called for much
tasting and sampling on our parts, and another
magnanimous promise from Rita that the score that finally
put his old man in Bellevue would be free. More
celebrating, tasting, and testing, festivities that were cut to
shreds by a hideous whine.

"You promised me a shot." No one looked at anyone.
No one spoke. "You promised me a shot!" Quickly
everyone moved away, leaving Ann's exposed mouth
opening and shutting on the floor. It was unheard of for a
ghost to speak. "Where's my shot?"

Only Rita moved towards Ann, smiling cordially. "Oh,
did I promise you that? Thank you for reminding me." He
pulled out a giant horse syringe. I had never seen anything
so big—the needle itself must have been nine feet long.

"You're right, I have your shot right here. Shall we?" His other hand pointed to the bathroom.

Even I knew Ann would be crazy to go in there with Rita. As the door shut, I was going to say "Don't," but my voice had disappeared. Anyway, you couldn't say no to Rita. I can't explain it. Rita was the most important person I had ever met in my life, and I still don't know why. Maybe it was chemical, but if you were high and Rita and the President were in the same room, Rita would be more important. That was Rita's charm: he was extremely impressive for no real reason. This was peculiar because Rita looked like a seven-foot cross between a truck driver and an insurance salesman: big biceps and tiny bifocals. He never acted gay and never raised his voice. The mild-mannered glasses framed a pair of screaming eyes that only hinted at the horror living inside his head.

Most people used only one word to describe Rita, and that word was evil. He was the dealer, and a lousy dealer at that. Trying to cop from Rita was a nightmare. His apartment was a bare room with several glaring sunlamps and one black chair that he would sit in, telling you to make yourself comfortable. In the dead of winter people would be sweating in there. If you didn't have sunglasses it

was hard to stay, but he would start insisting that before you scored you might like to watch his lover, Birdie, sit on a Coke bottle.

Of course, I never saw Birdie or this particular Coke bottle-sitting activity, but the fact that it was preparing itself in the next room put a definite edge on things. I didn't even know if there was a Birdie, but I did know that after an hour of this I would begin to seriously doubt my endurance. By the time I did leave I was so relieved to get out of there, I eagerly overpaid Rita and let him snort all my speed. Like I said, he was evil and his speed killed.

"She's dead. I said she's dead, you fucking moron. Don't you know what dead means? Well, it's right there, go refresh your memory." It was Rene R., who looked like a perpetually insulted egret and who spoke to the world as if it were stupid. What was he screaming about?

"She's overdosed. I walk into the bathroom and there she is, lying there . . . just lying there. . . ." Rita's voice serenely cut Rene off. "Shoot her up with milk."

What did that mean? There was no reply to that. And then I figured it out. Shit, it was Ann in there. Oh, my God. How long was Rita in there with her, an hour? It seemed like only two seconds had passed, but it could have

156

been the next day. The windows were sealed against lethal daylight, even the crack under the front door was gently covered by a towel. Although the apartment building had a doorman, we still worried about someone sneaking in and spying on us.

Did he say dead? There was someone among us who was dead? My head flooded with curiosity and I waded across the room to look. Orion glided out of the bathroom past me, looking very Egyptian and slightly bored. "It's only Ann," she sighed, her wake shimmering like the sun on the Nile. I went in and was amazed to see Ann not on the floor in a pool of blood, but in the bathtub fully dressed and half floating in dull green water.

Ondine sat on the toilet, as white as marble, white as fog on a black ocean, but not as white as the milk he was pouring into a syringe. "Ondine," I smiled cautiously, "I'm a doctor's daughter and I've never heard of milk curing anything." His eyes looked at me and then back at the needle. "If you're a doctor's daughter," he whispered, "what are you doing here?" He was right, I wasn't a doctor's daughter.

Carefully turning Ann's arm so that her vein rolled into place, I held it while he shot her up with milk.

Ondine's voice was comforting, "If you shoot them up with milk it prevents them from turning blue." Anything sounded fine to me at this point. I guess we didn't notice her head slide under the marbled water while we were giving her the hammer, so that, even if the milk could have saved her, we had drowned her in the process. Now she had to be dead. She looked dead, separated from us by a quiet slab of jade water. Ondine pulled her out by her ears and she slid right back down again.

That night, little soundless Ann rose from ghost to goddess. What else does one do with a corpse? She became sacred, our sacrifice to Ananke for the necessity of dying in the first place. We laid Ann in state on the coffee table— more celebrating, tasting, and testing. The mood was becoming festive, euphoric. Ondine was eloquent. "Ah, death, how good of you to come. You want a hat? No, no, we want to see your face." Ondine gestured grandly to us all. "Yes, by all means invite her to dinner. I doubt if you'll be able to stand it for more than five minutes. Now I have to strangle myself. Ugh, I am suffering from celestial rust. And you, you're all planetary detainees. Perhaps being born is your sin, and dying will be your greatest accomplishment."

"Yeah, fuck Heaven and Hell."

"Who said that?"

Nobody moved or spoke. Some people smiled, their
ears flattening back against their skulls like dogs.

"Show me the face of the imbecile who said that."
Ondine's voice dropped into its most deadly gear.
"Heaven and Hell—you pathetic slave to a table setting of
foolish opposites. My darling, language was invented to
conceal thought, but since you don't have any thoughts,
shut up. Since they put that clock inside your head, you
poor monster, you got stuck, didn't you, between
ignorance and immortality? The animals shun you and
God teases you. Good and evil, how boring; up and down,
ugh. What about nowhere, what about nothing that's
everything, what about the end? Well, there she sits, out
of the closet at last, no longer a mystery, poor thing. I
give you death."

And with that, the entire room shot up. Ondine was
right, we had captured death. She was lying on the coffee
table. We knew where she was. We could see her. You have
no idea what a relief this was, because if your neighbor is
dead, then you must be alive. More celebrating, tasting,
testing, and chatting with the corpse. It was religious.

"So your father is a doctor, Mary?"

Rita put his hand on my shoulder and smiled down at me, exposing a square hole where his front tooth was missing. I'd never noticed it before, but that hole was the entrance to the other side. I knew it, the decay, the blackness beyond. It was a little black door death had used to sneak in here. How clever.

"So, your father is a doctor, Mary?"

My knees buckled under the desire to tell Rita, "No. He's my stepfather. I wasn't born with a father, I'm not really connected with men. I was a box baby, a preemie. I was born so early I had long black prenatal hair everywhere and a spinal tumor that looked like a tail. Yeah, it was gruesome. I looked like a monkey. Every time the nurses rolled me in, my grandmother screamed at them to roll me back, you know, like I was some kind of mistake. I think it kind of set the tone for the rest of my life."

That was another thing about Rita, you always told him everything, usually in the form of a confession. There would be days when the only thing anyone at the Factory said to you was "I don't believe what I just told Rita." No one was above this humbling performance where you dragged your soul kicking and screaming into the light while Rita watched with the expression of a housewife

seeing her toilet backing up and wondering if this could be
the day when, due to a plumbing mistake, every shit she
had gotten rid of was about to reappear. I don't know why
Rita was the executioner, or why we needed Rita's particular
brand of punishment; guilt at being so high, or just more
Catholic shit? Rita didn't punish, he was the means by
which you punished yourself. I don't know if he planned it
or even liked it. Yet it was addictive, people waited in line to
attract his attention, eager for the high of being petrified by
the horror of themselves.

Now Rita, in the buff except for a towel turbaned
around his head, was at the piano singing *Tosca,* something
I was told he did when he felt upset. I was transfixed. I had
never seen a two-hundred-and-fifty pound naked fag
become Maria Callas before. He knew every word, and he
was dead serious, until the Duchess made the mistake of
mentioning the police. We tried to silence her, but it was
too late. The walls began to crack under the unbearable
emptiness that the outside held for us, paranoia lapped at
the sealed windows, the door shuddered like a dog and the
towel beneath it went black with water. All I could think of
was my parents finding out—I was an accessory to
murder—I was finished—I'd have to get a job and support

myself—Shit, I'd go to jail! Rita stopped playing the piano and stood before us.

"It's all right, I have a solution. Everyone will be immortal for five minutes. That's all we can afford for the moment. Life is not a bargain basement." What was he talking about? "But now we have to get rid of the body." He said it like the voice at the airport, "The white zone is for loading and unloading only." Get rid of the proof, of course, but how? We all started running in peculiar patterns. "Drag her into someone else's apartment." "Oh no, who's got a key?" "What if they're home?" If we took her down the stairs, someone might be coming up the stairs and discover us. If we used the elevator, the door would open and people might be there. My whole family might be in that elevator, just waiting to pour out on me.

But Rita was right, it was the law; if someone overdosed, you dragged them into the street. It had just happened to Eric, and they had left him with his bicycle on the sidewalk and told everyone he had been hit by a truck.

"Post her. Put her down the mail chute."

Ondine, how brilliant. More celebrating, taste, taste, test, test. Bring stamps. Address her forehead. Return address, Mount Olympus. Ronnie Vile, who normally only

drew subway maps of nonexistent cities, drew an incredible diagram of Ann's postal journey, of how this one-hundred-and-twenty pound girl could fit into a three-inch mail slot and be deposited eight stories down into the mailbox in the lobby. But there were some who didn't want to give her up, wanted to keep her. They insisted her death released life into the system, into us, and we would die without her. Wonton, who was an ex-construction worker, wanted to seal her up in the wall or at least flatten her out under the rug. He said that when he worked on the Verrazano Bridge they had sealed two dead hookers up in it for good luck. We had an argument, but it was settled; we let Wonton and the others keep her clothes. So now Ann was nude for her Valkyrian posting.

"Open the front door and drag her into the hall," Rita commanded. "Open the front door!"

Everyone stopped. Open the front door? We all shrank to the walls—we never opened the door. With the dignity but, alas, not the costume of a high priestess, Rita walked to the door and opened it. We cringed. The silence burned the fur we stuffed into our ears. Then, still very naked except for a well-draped towel about his head, he stepped into the hall . . . slowly . . . like a spaceman . . . leaving the ship . . .

without his spacesuit. We all watched intently to see if he would survive or shrivel up in the alien air. A couple of feet into the hallway he turned, smiled, and waved us on. Picking up Ann in silence we descended into the hallway, Rita in the lead. The pattern on the wall grew into dense foliage out of which foreign eyes watched us. The carpet felt spongier with every step down the murky corridor, when a foot suddenly kicked me in the mouth. I dropped Ann's leg, screaming, "She's alive!" Smash, she hit the carpet and sat up just as the elevator doors opened, revealing two 911 guys and Silver George, now renamed the Squealer. All of us shrieked and fled like roaches back to the apartment, barricading the door. No one came after us. Why should they? We were mentally ill.

Later Ondine told me Rita had given Ann heroin to shut her up. I asked him, "Didn't you think she was dead?" and he laughed. "No," he said, "gray people don't die. They're like rubber. You can't kill them. If you could, there wouldn't be any." How simple, and here I was worried about being an accomplice to murder.

These games were played constantly on thinner and thinner ice until we believed we could walk on water, while the people on shore shook their fur hats and fluffy mittens

164

as they watched us stand naked in the snow, chatting and tasting and testing. But I wasn't playing a game with Ondine, I meant everything I said. And I never looked down and saw the warm ocean licking the ice beneath my feet.

Vera Cruz

Chapter 9

THE TRUE CROSS

D o not imagine that I scampered around those velvet sewers completely unscathed. You cannot play with shit all night and come out looking like a boarding school virgin. No, no, no, you have some shit in your hair, and a little on your shoe, and soon you're talking shit. Every time you open your mouth it just falls out. If you hung with the Mole People, somewhere, somehow, either their drugs, one of their thoughts, or just one of their little hairs got into your skin and burrowed deeper and deeper, quietly driving you insane. It was the law, and nobody escaped, not even Andy.

The Mole People knew this law. They didn't jump out and attack you, they just smiled and waited. Nobody got to leave the playground, nobody. At first you think you're just

visiting, you're not one of them, then suddenly one sunless
day everyone crowds into your room dragging something,
something large and dark, and you know it's meant for you,
and they say, "Hi. Here it is. Your cross." Then they nail it
on your back, and that's it; all you can do is drag it around.
You tell them you didn't order this, it doesn't look good, it
can't be yours, but it doesn't matter. Your friends accept
your cross and, to your horror, even appear to like it. They
begin to identify you by it. Then the final insult: they invite
your cross to dinner without you. That's what happened to
me. The name of my cross was Vera Cruz.

She was a fan. I can never tell you how much I
loathed, despised, and prayed to God for this thing's death.
Looking back, I realize it was my extraordinary hatred that
brought her to the attention and later enjoyment of my
perverse friends, but try as I might, I could not stop hating
her. It was like trying to ignore a one-hundred-and-thirty-
five pound tumor, and that was how close she wanted to be
to me—me, who groaned at the thought of the hug, and
even considered the handshake a mild form of social
torture. She wanted to be inside my very skull, a voracious
boll weevil in my precious cotton brain. Nothing was close
enough. If I put my hand out, she tried to lick it. If I
talked to her, she wanted to fuck me. She was a bottomless

pit, ugly too—short with a little turd-shaped body one could only imagine floating dead in a porcelain bowl.

Long before you ever saw her, you heard her greedy, needy, sucking sound, caused by a perpetual case of neurotic asthma, followed by the breatholator pump, a grotesque little apparatus that she carried with her at all times. I still smile at the thought of her panicked gulps for the air that eluded only her, while I breathed effortlessly and deeply. To my delight, I found I could induce these hysterical attacks by focusing all my attention on her. Like a happy dog, she would get overexcited and have an attack—start to die right in front of me, emitting short desperate gasps that I wanted to gather together in one big fat death rattle, but she was always saved by a few sucks on the breatholator. Asthma was not her only physical problem. She did not have a vagina. Apparently God just forgot to give her one, a deformity that made her instantly famous in my crowd.

What did I do that the demons of the sewers should send this harpy without a hole after me, to shred my brain with her stupid beak and rip out my liver with her dopey claws? I don't know. Punishment for letting Violet strut her stuff on stage for a bunch of leather queens in a play called *Vinyl* that we put on at the Cafe Chino? It was a takeoff on the torture scene in *A Clockwork Orange*. We called it camp,

but actually it was naïvely pornographic, which was fine by me because everyone knew I was too high to have real sex. I told my mom it was a legitimate play by Ron Tavel; in reality it was a big hit with the S&M crowd, who would go wild as Violet and I tortured Gerard. And why not? Violet had gotten quite theatrical but was still authentic enough to attract a lot of very strange admirers. Gerard was lucky—he only got the whip. I got the cross.

She was waiting for me after the third performance, and I knew right then and there I was fucked. First, she showed me a shirt I thought I had lost, which she had stolen from the dressing room, but that wasn't all—what really unnerved me was a wadded-up, voodoo-like ball of hair that she insisted she had plucked from my hairbrush. She wanted to go home with me. She wanted to suck on my mother's tits. I took the most severe action I could—I asked Stanley to get rid of her. Stanley was a machine fag who guarded the Cafe Chino; you never messed with him unless you wanted your entrails rearranged. He threw her out, but the way he suggested I spend the night at the club rather than go home scared me. I watched his eyes. He was telling me this was serious, not just another dyke joke.

The next night the keys to a new Jaguar were delivered to me. I threw them in the gutter as fast as possible and left

the car glowing in the street. But too late, the black mark
had been delivered. She drove me nuts from then on.
During the performance of *Conquest of the Universe*, I
played the conqueror both on and off the stage, which was
how these experimental plays were directed by Vaccaro, our
homicidal genius of a director. I say homicidal because
whenever an actor was late he would close his eyes and say,
"I killed him," something we always disregarded until he
held up a performance by trying to strangle Patsy in the
wings. Every night he hissed in my ear, "Do anything you
like to them, I want fear in their eyes." I was all-powerful,
except for this troll I could not get rid of. Like the hump on
a hunchback, Vera mocked me at all times.

Ondine played the Red Queen of Mars, but even he
could not help. On stage he would whisper to me, "My
darling, I hate to be the one to break the news, but your
faithful boil is waiting for you in the dressing room. I
would be careful if I were you." Jabbing my fists into my
eyes, I would scream in pain to the audience like a tortured
animal, but Vera did not let go. She followed me
everywhere, or would be waiting for me when I got there.
She continually followed me to my apartment and even to
my parents', which I considered sacred ground and where I
struggled with her in the elevator until it was evident even

to our eighty-year-old doorman that she was enjoying it. For that matter, so was the doorman. When I planted my foot on her chest and propelled her out of the elevator, I distinctly saw the old guy smile and slap his fists. If she couldn't see me, she would call my parents thirty or forty times a day. She got to know all my friends and told them graphic sex stories about us. I couldn't stop her. I wanted to kill her.

Usually Vera Cooze (as my friends liked to call her—a subtle reminder that she was not sitting on both holes) never followed me into the subway. Either finding out from the friends I had just left or guessing where I was going next, she would arrive ahead of me in one of her stolen cars. But this time she couldn't know where I was going because I didn't know myself. This time it was different. I'd just fucking had it, that's all. I was standing alone in the IRT subway station at Fourteenth Street. I decided when I came down the subway steps and saw the platform empty (and, at 3 A.M., likely to remain that way), that if she followed me down, I would kill her.

The decision was made, and now all I had to do was wait. Soon I heard her wheezing, and saw her feet start tentatively down the stairs, but I didn't move—she had to come all the way to me. She was wheezing badly. She was

174

excited, she knew something was up, she couldn't believe how close I was letting her get to me. Maybe three feet from me she stopped and tried to talk, but I didn't answer. I was getting off on the adrenaline squirting into my veins, just like before going on stage or after getting really high. I was going to like this. If she came closer, if she tried to touch me, I was going to do it. She reached out, and it was so simple, even graceful. I grabbed her arm and, swinging her off balance, I shoved her off the platform and onto the tracks. Then the train came and smashed her skull into her asshole.

Correction. Then the train was supposed to come, but it obviously missed its goddamned cue. I really felt kind of lightheaded. The subway station was weirdly quiet except for this dry scraping and gulping sound. It was Vera, having an attack and trying to climb up at the same time, but she was too short to reach the platform, and too out of breath to scream for help. Disgusted with the bad timing of the train, there was nothing for me to do but watch. I don't know, I was kind of proud of not giving in to the rescue urge, and a tiny drop of satisfaction came when I saw Vera's eyes understand that I was not going to help her out; but mostly it was boring.

Things picked up when we both heard the train

coming. First, I watched her run by me to the nearest end of the platform where there were stairs, but as the train got louder, she freaked out because she was going towards the sound of the train; so she started running the other way, and I got to watch her run by me again. This was too stupid; I felt like a spectator at some bizarre sport. What was I supposed to do, cheer? "Come on train, flatten the bitch!" My voice was so loud, I was afraid I'd scare the train away, but no, it came all right—to the wrong side of the platform. I couldn't believe it, it was the express. I also couldn't believe that people were getting out of the train to witness my first attempt at murder, but they just headed for the stairs, totally oblivious to Vera sucking and stumbling over her breath pump on the other track. Even if they did see her, they couldn't have cared less at that time of night. New Yorkers were so cool.

I could see the lights of the local lumbering along. It seemed to be moving slower than Vera. Fuck it, I jumped onto the express, and heard those steel doors smash shut, but this time with pleasure. I said one last prayer: "Fucking crush her, man, just fucking crush her!"

It feels good to have finally told this. I never told anyone, and now I'm telling everyone. I'd even do it again.

I didn't bother looking in the papers for the news of Vera's death. I didn't care if she was dead, but I was amazed at myself, at my total lack of guilt. Feeling positively giddy, I went to Max's, straight to the back room, the dreaded back room, where I was immediately greeted. "Mary, Mary, come over here. Sit with us." It was Andy's table. They were actually throwing someone out of the booth to make room for me. I pranced over, sat down . . . and painfully realized why everyone was smiling at me. Vera was tucked under Andy's wing like a pet viper. This was going to be really ugly. I could see by her smile she had told no one about what had happened in the subway, nor was she going to because the secret formed a bond between us that gave her power. I was no longer innocent and she knew it.

I began to doubt my sanity. Was she capable of resurrection, or did the incident in the subway not even happen? I stared at Vera as she pulled out a vial of yellow liquid. Andy couldn't contain himself. "Oh Mary, Vera's been telling us that this is your piss. You've been letting her collect it for some time now. Why didn't you tell us? Gerard, why didn't she tell us?"

Gerard: "That's disgusting, Andy. I don't know."

Paul: "Vera's going to be in our next movie. We're

going to have her collecting everyone's piss. That should be entertaining."

Andy: "Yes, maybe you should do a sex scene with her, Mary."

Vera: "A love scene."

Paul: "No, no, Vera, that's too ugly. Nobody wants to see that."

Andy: "No, we can do that. Oh, Mary, where are you going? Don't you want to do that? Where is she going, Gerard?"

I knew what they wanted. They wanted me to throw a scene, to beg, to fight with Vera. Well, forget it. I left. She had won, so let her gloat in the back room, take my place at the royal court of screaming assholes. I banished myself. I slid back, back into the shadows where old queens apologize in runny make-up, and toothless speed freaks mumble incoherently. Shit, I slid so far I practically fell off the map. People I normally wouldn't talk to, I was getting high with now. It was limbo, full of ghosts and exiles like myself. It was okay, quieter, no spotlights, no splashes, just water, running, running full force towards an ugly drain. Ondine found me sitting by this stream, licking my wound. It wouldn't heal. Even here at the bottom, I hated Vera.

Ondine said he had come to get me. I was having trouble focusing . . . I couldn't even sit up, but I tried to follow his voice. After all, he was the Pope, our shaman (my legs buckled), the alchemist. Maybe he could cure me, absolve me, help me, or just turn me to stone.

Ondine's voice stuttered over words like water laughs over rocks, and at first he sounded very far away. "No, you cannot stay here. It's too dangerous. Of course, it's one of my favorite places, but—here, take these. I got them from the Turtle, they're divine. Now, you must come back with me. I miss you. Jack Smith wants me to do this movie, and you must do it with me. Fuck Andy and his pet vermin of the month, besides, I have news. Vera's gone. Yes, my dear! To a hospital in Arizona. Her lungs collapsed, isn't that divine? I knew you would be pleased. No, I didn't do it, but I know who did. I took you-know-who to her house, you know how she loves to torture people. She started playing with her breatholator, kicking it across the floor, while Vera was lying there making fish noises, you know, those disgusting sucking sounds, when all of a sudden her face looked like it just went under water, and her lung popped. I was horrified, but then I thought, how wonderful." His brown eyes smiled into mine. "Didn't you think I would avenge you, my dear? She was too undignified to live." I

stood up like Lazarus, not because Vera was gone, but because Ondine said he missed me.

I did Jack Smith's movie with Ondine—well, I think I did it. We waited in an old warehouse on Hudson Street for hours. There were bundles of rags and old clothes around, mountains of them, but I don't remember seeing a camera. Much later we discovered another couple waiting also. They were cooking over a makeshift fire and they said they had been there for at least a month. When we finally left I could not tell if we had shot a movie or not, but I was definitely missing a couple of days. Anyway, I was so pleased to be working again that I hardly had time to be upset by Vera's return, but I was told that she had come back with a man-made vagina. Apparently when they were uncollapsing her lung in Arizona, she paid them to slap in a new cunt while they were at it. To prove the reconstruction of her vaginal area was a success, she invited first John Cale and then Louie Walden to fuck her, which they both did. Later, I spoke to Mr. Walden about this appalling incident.

"Louie, how could you fuck her? She was so disgusting, so ugly, so not human. It wasn't like you were hard up. How could you do it? How could anyone?"

"Look, Mary, I know you hate her, and believe me, I

don't like her either. I mean she isn't that bad-looking, but she's off. Hey, it was an adventure, I had to feel what it was like to fuck a man-made . . . ah . . . well, the latest thing in . . . you know, if it was any different."

"So, how was it?"

"You really want to know? Well, she didn't have any lubrication, so she filled it with a whole tube of Pepsodent toothpaste. She liked the way it felt, and we fucked. I couldn't really feel—"

"I don't want to hear any more."

"You know, she had a gun with her the whole time we were fucking. She said it was for you, to shoot you in the cunt. And then she made me promise not to tell you, that's why I never mentioned it before now."

"Thanks, Louie, you're a real pal."

We both laughed, Mr. Walden and I, because we are survivors. Louie put his hand on my back where the cross used to be nailed and it was smooth—not a mark on it.

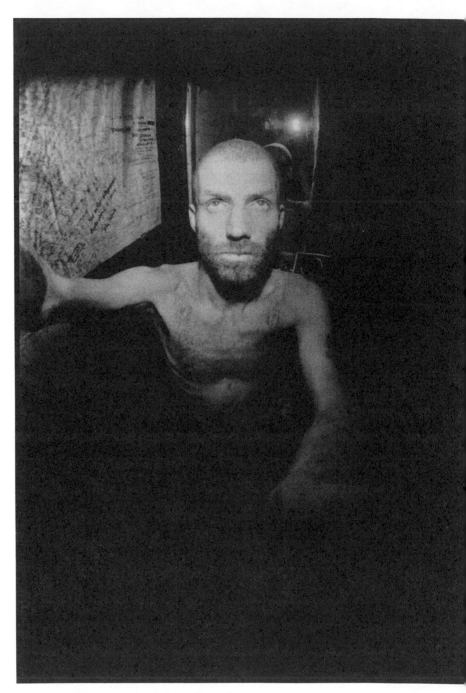

Billy Name buried in the wall

Chapter 10

VAMPIRE NEST

eath was in the air. My attempted murder was having this strange effect on me, this feeling of immortality. People were calling us the undead, vampires, me and my little brothers of the night, with our lips pressed against the neck of the city, sucking the energy out of scene after scene. We left each party behind like a wasted corpse, raped and carelessly tossed aside. I couldn't believe it—the richer, more intelligent the party, the happier they were to see us. You could vomit words or dinner, it didn't matter, they treated it like art. We never ate, we laughed at their food. Sneering at their jokes and snickering when they were serious, we stole useless objects (priceless to them) and combed their medicine cabinets for drugs.

Andy was the worst, taking on five and six parties a

night. He even looked like a vampire: white, empty, waiting to be filled, incapable of satisfaction. He was the white worm—always hungry, always cold, never still, always twisting. His favorite lair was still the balcony of the Dom, and my favorite place was right next to him, watching the sea of swirling bodies flop about below us like fish in a net. Suspended from our cave ceiling, Andy and I hung like bats, often mesmerized by the same dancer. That night we were watching a blond girl, kind of like Edie, when a smell made my skin tighten and, looking up, I saw Ronnie Vile. "Ondine's downstairs," he whispered, and disappeared.

I looked back down at the blond, her back arched in the attitude of the victim. I knew that arch, I knew the message that it sent—I used it many times dancing on stage while the Velvets stumbled through "Heroin." Andy grinned and asked me if I liked her, the dancing blond with the victim on her back. I figured I'd say yes just to give him a little thrill, but the lights went on and everybody went nuts trying to find out where everybody else was going next. Andy whispered in my ear, "We're going to the Laundry Shoot." It was so great being part of the in-crowd.

Ondine and I found each other and got into a cab. His

handsome face smiled back at me, his voice curled about my heart, the same voice that left egos dangling like abandoned marionettes, but he never did this to me— instead, I watched him do it to others. I was even a little bit jealous of his victims—or his lovers, I never understood which were which, the ancient boys and infantile men who stumbled out of the bathrooms after him with only the empty air of his wings left on their cheeks, while he soared scornfully out of reach. Except for Roger, whom I believe he really did love, he never looked back on his victims, but I did. I always said hello when I saw them hanging in the background, or smiled politely when they whispered, "Where's Ondine?" But they would answer their own question by disappearing before I could point him out to eyes too starved to see. If Ondine was a vampire, then I was Renfield living happily on a sexual diet of bugs and fleas, returning home to Brooklyn once a month to sleep in my childhood bed as if it were a grave and I was rehearsing for my death.

"You must come with me, my dear. I'm on a mission."

"Yes, yes, of course I'll come." Leaning back in the cab, we both produced tinfoil packets of speed and offered them to each other.

"Oh, thank God you're here. I have to deliver Mme Blavatsky to Billy."

I looked around the cab. "Where is she?"

"Right here." He pulled open his coat, revealing a large dark-blue book. "Theosophy, my child, from Russia, out of the heresy of the Cathars, kept alive by the Rosy Cross and poetry, to battle the evil Society of the Green Glove that told Hitler to make a human sacrifice to the gods if he wished to conquer Russia, which is why he killed the Jews." If it wasn't for Ondine, my head would still be a wooden bowl filled with the propaganda porridge that was slopped out in history class. His retelling of history was truly inspired, and with amphetamine enthusiasm we discussed theosophy, astrology, and fatality all the way uptown.

When we got to the Factory my good mood took a sudden dive. The place was deserted. Ondine left me and went directly to the back, dropping to his knees before a small slot in the silver wall. This slot was all that was left of Billy Name. A month ago he had buried himself alive inside the wall of the Factory, just plastered up a bathroom doorway, leaving only an opening at the bottom for drugs and books: the *I Ching*, the *Kabbala*, *The Tibetan Book of*

188

the Dead, and now Mme Blavatsky. Some thought Billy was
in trouble; we had seen it before with other speed freaks
whose time was up. They begin to live in a smaller and
smaller world till finally they are living in the closet, then
part of the closet, then on just one hanger, till they let go
and fall into nothingness, like out the nearest window. But
others believed he had buried himself alive like a mystic,
renouncing everything till he became invisible. He couldn't
be crazy; crazy people didn't read the *Kabbala.*

Billy's rapid slide from feared monitor of the Factory
to a voice trapped inside a wall had everyone unnerved. He
had been the Factory's protector; not only was he
responsible for its silver foil decor (using the inside of his
Camel cigarette packs as wallpaper), but he had been in
charge of who was allowed to stay there. Andy had no
guardian more loyal. Everyone trusted Billy; you could leave
the *Mona Lisa* with him and whenever you asked he'd
return it. But now all that was disintegrating like a castle of
ash. Billy was near death, he had already vanished, and we
were scared.

Lou became a vitamin freak, swearing the right
combinations got him high. Die-hard speed freaks switched
over to pregnant mothers' urine for their high (Orion had

started it by drinking her own piss and claiming it made
her young again), and there were rumors of the rich
changing their blood in Zurich, using monkey glands in
Prague, and sheep bladders in South Africa. The queens
who could afford it became plastic surgery junkies, living
their lives in hospitals, preferring to change their bodies
rather than their surroundings.

The only one who seemed to glory in the oncoming
wreck of his body was Ondine, and this he did with a
vengeance, a rage against the mortality that was threatening
his friends. He would not care for himself, falling asleep in a
chair or on the floor instead of a bed, destroying food
before it ever reached his mouth, like the time he insisted
on hand-mixing a salad at Max's that was then dumped on a
girl's head because her ears were so long he thought she
might be a rabbit in disguise.

Sweat broke out across the bridge of my nose. I knew
the symptoms: the speed was bad. The elevator door
opened and Warhol stepped out, alone. I had never seen
him alone before. It was strange, but after all this time
something in me still wanted to protect him, just like Billy
had always done. He walked across the Factory floor as if it
didn't belong to him, as if it had a life of its own that was

out of control. Hurriedly he joined Ondine. They were whispering about Billy; I knew Andy was afraid he might die like Freddie, like Danny, like Eric who wasn't going to fuck anyone anymore, like so many others. Andy was worried people were going to say he kept someone buried in the wall for years on end and . . . but I couldn't pay attention, I was sick.

I lay down on the floor. Someone had cut the speed with arsenic, or maybe it was acid. I rolled over, and that's when I saw her, a large woman dressed in endless black, sitting motionless on the cum-stained silver couch. I could smell and feel her too, a bad smell and a cold feeling, like the refrigerator door had been left open. Horrified, I saw she had gone through Billy's carefully organized stuff, which was now scattered about the floor like the bones of a recently eaten animal. She had long, horrible teeth, and she was smiling at me. I could tell she was waiting for Billy and she didn't care if I saw her or not. She'd catch him for sure, and then what would she do? Eat him like an animal? Drag him off somewhere to the caves beneath the subway system?

I climbed to my feet and stumbled over to Ondine and Warhol. I had to tell them, the Factory was a trap and we

had to get out. "It's death," I babbled. "I just saw her sitting on the couch. We've got to get out of here before she gets us. Let him die."

Ondine whirled around on me, his brown eyes gone black with fury. "Let him die? Let him die? You coward. You stole Billy's vision; now you can choke on it."

"Tell him to take it back, I don't want it. Let's get out of here."

"Shut up. Crawling around on the floor with your mouth full of dirt, you can't run from a vision! It's wasted on you, you premature appearance without a second act. Continue, scream if you must, but not around me because I'd just as soon take out your tongue and nail it to your foot. Go, join your animal friends, less than pigs, those soft white shapeless housecoats folded neatly on the shelves of Brooklyn. I will stay here and detest you for the rest of my life with more devotion than you deserve."

I went blank. I couldn't leave. With all of my circuits down I dangled helplessly, waiting for the power to return. Slowly the fog of humiliation lifted over a city of rage between my ears—I wanted to hurt Ondine. I could never talk to him again. Even when he apologized in the cab on our way to the Laundry Shoot, I still could not speak,

could not say it was okay. Soon Andy and he stopped talking and we traveled in silence, except when Ondine whispered in my ear, "You're too proud like Orion—I like it, a much maligned quality—after all, if it wasn't for Lucifer we would all be sheep."

Orion. The name entered my brain slowly. . . . Since she had disappeared one day without warning, Ondine and I had been much closer. Some say she married an English lord, but Ondine said she had turned into a bird and sometimes she haunted him. He could hear her tapping on the bricks in the wall or he would see her perched on some garbage dumpster looking at him. I could tell he missed her and that made me feel worse. Even in her disappeared state her powers remained; people told stories of apartments spontaneously combusting after she left them, and about how Silver George's friend got meningitis when she looked at him. I wasn't anything like her. She was a witch, a murderer—I was only an attempted murderer. But that didn't make me better, it just made me smaller.

The Laundry Shoot was an after-hours place where the customers kept their drugs, alcohol, and sexual equipment in little gym lockers that lined the walls. Inside,

I immediately started getting bombed. Intent on showing
Ondine and Andy I could have fun without them, I talked
a little too avidly to everyone around me, ending up in a
corner with Jackie Curtis, a drag queen who never wore
hose without runs or a bra you couldn't see. She was a
tramp vamp, a normally funny guy, but last week she
locked into numerology and now her voice rattled around
and around inside my skull like a marble in a dish.

"You see, the sacred number is 142857, composed of
7 twice, 4 times 7, 8 times 7, with the ego added to the last
figure. Isn't that wild? Do you have any drugs left? Now,
take any number and place it with a reversal of itself and
subtract one number from the other and the difference will
always reduce to nine, and is always a multiple of that
number. Any speed? Mary. Mary? Are you with me?"

The next thing I was aware of was the steady cold
pressure of pavement against my head and large shadows
over me, shadows of black leather with silver zippers and
silver belt buckles and silver rings. My head lay on its side
like a jar that had rolled off a table and I lay alongside it. I
knew something sexual was going on and it was going on
near me, but so far as I could tell it did not involve me.
Slowly I recognized the alley in back of the bar, a place used

by my friends to butt-fuck their brains out—an activity that I really didn't mind, but one that I didn't quite feel I should be watching. Now I was too embarrassed to wake up, but I could hear the shadows talking about me.

"She looks dead."

"So what?"

"She's not dead. She's playing possum, let her watch."

"Shit, we all want to watch this one." Then there was a groan as the heavy, sexual pressure under their voices shifted. The shadows above me moved away. One of them said, "She's over here," and Ondine's voice erupted out of the darkness.

"Mary, I knew you didn't go home. What a fabulous idea to miss the last half hour, it was so tedious. I've done everything I can to miss at least two or three hours a day but it hasn't worked for years." He turned and addressed the shadows, "What are you waiting for? Couldn't you pull your fist out of his ass long enough to put a shoe or a coat or a pillow under her head? You see her face is on the cement." The shadows laughed.

"A pillow? Do we look like we carry extra pillows?"

"Who's got a fuckin' coat anyway?"

"I have a ball gag, how about that?"

"Prop her up, she's having a great time."

Ondine's voice dropped to a lethal purr, "Don't get fresh with me."

"No, get fresh with me," the owner of the voice stepped out of the shadows. It was a young boy. His white body glowed in the streetlights like an angel, but when he smiled two long pointed fangs slid over his bottom lip. I didn't say anything—it had to be a joke. Then, squinting hard at the other shadows, I realized they all had vampire teeth. Drops of blackness spilled over the rim of my sanity. I wondered if Ondine's teeth were normal. I tried to think . . . but all I could think of was what if Ondine's teeth were like that? If they were, I was checking into Bellevue. I needed protection. From the ground I watched Ondine's face. I could tell by his eyes he was about to smile.

"I wish you would get fresh with me," the young boy repeated, staring straight at Ondine.

"Maybe some other time," Ondine smiled, half flirting, half sad. "Now, come over here and help me pick her up." All his teeth were pointed, and the two fangs on either side were as long as a dog's, but he just kept on talking, "Umm, really Mary, of all the meat racks to pass

196

out under." The blackness was pouring down the sides of my mind; I had to keep on cleaning it up, pretending it was an illusion.

Back in the bar, Ondine was not much help. "Confidentially," he whispered to me, "these teeth are too melodramatic and it's so difficult to eat, and as for sex, well, frankly I find them quite awkward."

Hours later the fangs still hadn't gone away. All my friends had them, and I couldn't bear watching them talk. All I wanted was to return to my little apartment and Jane and never leave again, but I was afraid to go there, afraid she would have fangs too. What if I went home and my brother had baby fangs? From between the legs of the chairs and tables, as if out of a leafless forest, came the coyotes. They sat on the floor inches from my feet, waiting.

That did it. I had to get to Bellevue. I started begging everyone in the bar to take me there. "Look, I think maybe I'd better go to Bellevue. It's serious and I'm scared, so please please put me in a cab, take me away, please. . . ." But Ondine's voice ripped through the air; no one was to take me to Bellevue no matter how much I begged, and finally it was decided that the Duchess would take me with her that morning to Bridgehampton for a rest. She went

there every so often to visit her friend Charles, and she went in a limo.

On the way, through the tinted window, I saw things running alongside the limo. At first I couldn't make out what they were, but then I recognized Orion's hair, Danny's glasses, Freddie's arms, Eric's smile—it was everyone who was dead or missing, and there were so many of them. When I saw Billy, I stopped looking out the window and started to cry.

We arrived at dusk, just as Charles was waking up. The Duchess had told me the only rule was never to wake Charles during the day. He habitually stayed out all night, wandering back from the beach at dawn disheveled, exhausted, and sometimes bruised. He was a huge man with a powerful barrel chest, and for a moment I thought my collarbone was in danger as he hugged me and laughed through fangs the shape of wild boar tusks. But he was very concerned when the Duchess described my disorder. Charles collected things, living things—stray dogs, cats, and girls; besides the Duchess and myself, there were two other girls: Luana, a Brazilian heiress, and the beautiful but deeply depressed Harriet. We all had our own rooms in a Victorian house that Charles's lover had left him along with a rose

garden, a swimming pool, and a lot of potato fields. However, the only thing that impressed me was the refrigerator. It was filled with amyl nitrate poppers, my favorite imitation of sudden death.

After a dinner that nobody ate, I went to my room. From my window I saw Charles standing on the front lawn as if he were smelling the air. After a while, a taxi pulled into the drive and he got in, but the cab didn't go anywhere. It just stood there with the motor running while the moonlight flooded the ground in summer snow, the cabbie's knuckles gone white on the steering wheel while his red blood squirted down Charles's chin—my brain, I had to shut it off. Curling up in the freshly made bed, I prayed as the shadows of branches soundlessly crept across the walls towards my neck. "If I should die before I wake. . . ." Oh, Jesus, she's in the room.

She was crouched in the corner of the room, eating something off the floor. It was the old woman dressed in endless black. When she looked up this time there was no question she was there for me. She had the face of my mother but much older, her ancient decayed mouth coming closer for her good-night kiss. I steeled myself against her putrid smell, the mouthful of bitter dust, but as her lips

touched mine it was like biting into a purple black plum whose fruit was brilliant red, like an explosion of intense joy. Its childhood smell wrinkled my nose with pleasure, its sweet juices ran down my chin, turning into a beautiful black ocean where I floated safely, not lost as I had imagined, but securely tucked away deep in space.

Three days later I woke up with the strangest feeling, good old-fashioned hunger. The Duchess started feeding me omelets with garden-grown zucchini and performing three-point dives into the pool in her makeshift sarong. I had to hand it to her, she was fat but quite graceful. Everyone was better looking without their fangs, but I couldn't stay. I had been given a second chance; what I wasn't aware of was that most second chances turn out just like the first.

Charles drove me to the station in his old Mercedes, and on the way he told me what he thought, whether I liked it or not—that's how he was. "You should stop fighting so much. Everyone falls in love, my God, it's one of the few nice things we do, and I'm just sorry I didn't do it more often, but, you know, I did it once, and even after Jerome's death I never regretted one moment. I still love him, and I don't regret that either."

I didn't want to hear this sentimental shit. Who did he think I was anyway, some stupid fag hag? I loved no one, be it man or woman, no one in the human-skin package.

When I returned to the city Ondine and I became a team again, so much so that John Vaccaro couldn't decide which one of us should play the emcee in his new play, *Nightclub*. In a flash of brilliance he had both of us play the same role. Like mirror images of doom we went on in matching tuxedos. I repeated the same line seconds behind Ondine; he sincere, I mocking; he feminine, I masculine; he nice trying not to be vicious, I trying to be vicious but obviously nice; both of us for some reason likable but for every reason not in any way alike. Each night my tuxedo was immaculate while Ondine's seemed to disintegrate during each performance. He made us all uneasy by either ripping it up or adding to it or smearing his makeup on it. At the end of the play, when we could no longer entertain the audience, Ondine would ask me, his other half, to cut off his head, and every night the blood from his neck stained my hands like some kind of omen . . . but that couldn't be . . . I would never hurt Ondine.

Ondine, the Pope

Chapter 11

THE
FALL

"Ondine, I don't have any. It's all Gerard's fault, he scared me. He twisted my arm while I was dancing and then he hissed in my ear, 'You're doing too much. You're mumbling. Your lips are black and nobody can understand you.' I don't know why he feels he has to protect me, probably from that time when my dad told him to look after me in California. Anyway, the shithead scared me so much by saying I looked gray that I ran into the bathroom and gave away all my dope—just handed it to the first outstretched palm I saw."

Of course, Ondine didn't have any either, and his story was even more convoluted, a veritable gothic cathedral compared to my simple confessional. Night was just

beginning and already we were weary; Ondine's handsome face seemed more ravaged, blotchy, whiter. The shadows were always with us now. I knew we could not continue like this, that he was unhealthy. Somehow he had gained an alarming amount of weight that lived like an animal under his clothes. He never mentioned it, but I knew it mortified him; so I became skinny enough for both of us. One day I fainted on the subway trying to get to a modeling gig— Twiggy was in, so I was delighted with my new look, eye sockets balanced on cliff-bone cheeks that seemed to rise up out of my jaw without the help of any connective tissue. I was only twenty, but I looked forty.

I was watching Ondine, and his beautiful brown eyes looked back at me through the glass of the pay phone where he was trying to cop. Dimly I realized that Charles was right; I was in love, but I thought if I ignored my feelings for Ondine so that no one knew, he would not be taken away from me. Ondine made a sign and I knew he had scored. As I snared a cab he came flying out of the phone booth and insisted on opening the door for me.

We went uptown where the drums said Rotten Rita was running, but when we got there all we could find was

the Duchess. She was in tears because Rita had ripped her off and left her standing in the street. Pissed off that we had come all this way for nothing, I saw no reason to get out of the cab; instead I accused her of holding out on us. Her tears were instantly replaced by a snarl and I barely got the window rolled up before she attacked the cab with a running belly flop. It was like being at the aquarium. Through the glass window we watched pieces of her body flatten out and then pop back, her eyes bulging carp-like, her mouth opening and closing, "I'll get you for this." Too chickenshit to scream at Ondine, she directed everything at me. "I'll fuckin' pay you back, you bitch, you'll die." When she started banging her forehead on the window I thought the aquarium would break and she would pour into our cab with the liquid night. Ondine and I grabbed for each other and burst into laughter as the taxi pulled away, reducing the Duchess to an angry guppy swimming in the rearview mirror.

In the small East Village apartment Jane couldn't sleep because of a party going on next-door. There was laughter, then crashing sounds and more laughter, then a knocking on her door. Jane didn't know the visitors but she let them in

anyway. It was the fat lady and the crocodile. The fat lady was talking nervously, and it was unclear if the crocodile was her pet or the other way around. The crocodile was lifeless until he saw his prey before him, then the leash snapped, and his eyes locked onto his victim. He looked at nothing but Jane, who was trying to be polite to the fat lady. "Get out of here, Duchess," he said. "Leave now."

My rat was wide awake and hungry for drugs—it wasn't funny. In desperation we went to Stanley's where I stared at a speed freak's dream, a wall completely covered in purple three penny stamps. Curling up on the couch, I shut my eyes and saw stamps anyway. Square by square I started replacing them with little pictures of the apartment that I had with Jane; the floor we'd ruined with our oil paints, the sunlight on Jane's homemade curtains, the *New York Times* she bought every Sunday for us to mess around with and smoke cigarettes over, the kitchen utensils that never made it out of their boxes.

I wondered why Mom thought giving us kitchen utensils would make a difference. They hadn't straightened out any of her unnatural habits: like her habit of standing up in the middle of a restaurant or at a party and just walking away—out the door, into the street, into the next

state if no one stopped her. She would just drop her groceries or her laundry or her keys and start walking while I ran after her, and my father and brother looked the other way. What made her walk off like that? The same urge that propelled bag women to migrate and gather their mysterious piles of stuff? My brother and I often discussed why our mother, for no discernible reason, moved large piles of stuff around our house, stuff she was continually "sorting out." We tried charting the course of the piles to find some logic but the secret of their movements eluded us. I would go to bed and wake up in the morning with an uncomfortable feeling, and there, next to my bed, a large pile of unexplained stuff would be waiting for me. My brother and I attacked and pulverized the piles but they always reappeared. Another pile would be in the bathroom, preventing me from combing my hair. Frantically, I would look through it to see if my lost barrettes were there, if the rest of my life was there, some explanation. Seeing the bag women push their shopping carts of mindless garbage, the material form of my over-stuffed imagination, I could not suppress the suspicion that Mom and I were somehow of that same tribe, that our roots were as wild as their hair, and our fate as nomadic as the pointless directions they

walked in. Empty shopping carts outside the supermarket could fill me with the same dread a dying man develops for vultures.

"Mary. Mary?"

The crocodile was no longer silent; now he talked and gave her drugs, more than she wanted or could handle. There were lines of white powder between them. Since it didn't seem to affect him, Jane didn't think she was high. Instead she felt infatuated with him. His face was hypnotic, not handsome, but very sexy and cool like a deep-sea fisherman, a seasoned hunter, a quiet killer. He said he loved her, fed her the long line. It wrapped around her brain, tangled up her thoughts, drained her freedom so that she couldn't move, only squirm a little. The bondage excited him and he brought out a real pair of handcuffs. Jane laughed, putting both cuffs on one arm like a big silver bracelet, and she continued laughing as the bracelets lay on the table in the white powder waiting for her. Every time she trusted him she slid into deeper water, until . . . splash! He accused her of lying. He sulked as the water darkened and it was Jane's turn to reel him in, to reassure him. She had to go even farther, do something for him, tell him she wanted to make love to him. Slowly he rose to the bait but he did not swallow,

he only nibbled her ear and said, "No, not yet baby," but he did want her to undress.

"Mary, they don't have anything. We have to go to the Turtle's"—the same Turtle whose head projected out of his back as if out of a shell, due to a missing vertebra. I stared at Ondine. He had wrapped the most hideous yellow scarf about his neck. It was so ugly I wanted to take it off but I knew that was useless, he would only find something worse. "Okay, let's go," I smiled.

Outside it had started snowing, and I forgot about getting high. I started laughing and sliding about on the slick pavement, when Ondine caught me in his arms and for a moment we stayed like that, for a moment I felt his incredible loneliness, the loneliness of a man who understands too much. I threw my arms around him thinking I could make a difference, and when he kissed me, I kissed him back, breaking my vow. Sunlight exploded onto my dark world, and under all the ice—spontaneous combustion—feelings I had banished from my kingdom so long ago reappeared. As we continued walking and holding onto each other I noticed music playing between the snowflakes. Maybe the air had always had music in it, but I'd never heard it before.

*Jane was beyond naked, she had deteriorated so much in
the last two or three hours that it didn't matter to her whether
she was wearing something or not. The man was the same,
watching, waiting. He had not lost interest; if anything, he
was falling in love, not with her, but with her struggle. Every
time they were about to make love he accused her of something
else. He slapped her. Another strand of civilization snapped in
Jane's head and she stumbled into a new arena; she didn't
know whether to get up or lie there. She just kept looking
around, not recognizing anything. No one had ever hit her
before and he smiled because he knew he was the first. He
kissed her, finally, and caressed her with his tongue,
explaining and apologizing. Jane whimpered in his arms like
an animal in a trap, confused, but very aware that she was
fighting for her life.*

In the Turtle's bathroom both of us finally got off.
Things fell back into place, and I was invincible again—
vagrancy, bag-woman syndrome, fear—all floated back into
the distance—I was too smart for that. You see, I had a
system: there are two houses, good and bad, order and
chaos, whatever—if you lived in one, the bad one, all you
had to do was spend an equal amount of time in the other

to neutralize them, like confession nullifies sin—God, this speed was good.

I was conducting my life according to these rules. Jane was my passport back over the borders of sanity, proof that I was not a victim like everyone else around Andy. Of course, Jane's parents hated me, but they need not have worried. I had kept Jane far away from Warhol's group of ghouls. Occasionally, I brought something home to turn her on, a drug or a story. Jane could be very gleeful at these times, but mostly I kept her pure.

He dressed Jane carefully like a mother would a five year-old child. Most people would have abandoned her at this point, but he was unafraid of being close to her now. Now that she was broken, he seemed married to her. His voice was steady like someone trying to talk a plane down in a blizzard— "Come on baby . . . come on . . . we gotta take a visit . . . friends of mine . . . get you a shot, bring you back down . . . then we'll make love, okay?" "I can't go out," Jane mumbled. His voice came back in, soothing and calm, "You gotta, baby, you're too high . . . I'll give it to you . . . I'll pull down your pants and skin pop you . . . you'll feel good . . . trust me." Jane's eyes searched the empty whiteness for a recognizable

object. All her instruments were printing out the same message—out of gas—emergency. Her captain just stared at the screen and shook his head, his hands tied in white powder. Jane made her last attempt, "Okay, get me the shot," and with the thinnest sound, her will snapped. Drawing her close he whispered "Oh baby, good girl. . . . " Seconds were precious. Clutching his broken toy in his jaws he disappeared into the night. Outside, snow fell as he put her into a cab, and when he brought her back the world was different, she was floating just like he promised, and all of New York was under a cozy white blanket.

When I showed up outside our apartment, a party was going on full tilt next-door. It was an eviction party, where the abandoning tenant invites his worst friends to do as much damage as possible. Garbage and blood spilled into the hallway, and as I fiddled for my keys, the filthy guests, some homeless, others just mindless, stared at me through drug-rimmed eyes before returning to carving meaningless holes in the walls.

Shutting the door behind me was not a relief; the sense of violation had definitely permeated our apartment. It was not in its normal mess, it was in an alien mess, and little Plain Jane was not snuggled in her regular bed and

pajama set. Under the bathroom door a light was bleeding slowly. I knocked. No answer. "Jane?" No answer. The next step would be to open the door, but instead I timidly knocked again. "Jane?" Something dropped on the other side of the door and rolled across the tile floor. The sound trickled down the inside of my ear. Cautiously I opened the door.

"I dropped my lipstick." Jane was on her hands and knees, grinning from ear to ear. While I stared at her she became engrossed with the floor as if it were the newspaper, her head nodding lower and lower in sightless scrutiny. Shit, she was on smack. Someone had given sweet Jane the hammer, but why? Why would anyone want to nail her? Fear slid into my stomach like a cold eel; I didn't know if I should throw her into the bathtub or fill her with coffee. Frantically, I decided to make the coffee as Jane leaned into the mirror to apply eye makeup like a blind person threading a needle. She thought it was pretty funny. In fact, she was having such a good time, I drank the coffee instead while I tried to find out what had happened.

"How do you feel?"

"Great . . . now. Will it be bad later?"

"No, you gotta take a lot for that to happen. You'll just go to sleep."

"I think he gave me a lot."

"No, I mean a lot of times, you gotta take it a lot of times, not just once. Jane, tell me what he looked like."

"He had these pale blue eyes . . . cold but hot . . . he made me come every time we did it . . . about ten times."

"Nobody comes that much, it's physically impossible."

"For you, ha ha . . . hahhahahah. Maybe . . . that's why they call him the cockadial . . . ha ha ha ha ha. J. C., dial-a-cock."

Jane just couldn't get over how funny she was being, but my mental Rolodex was on spin—J. C., Jimmy Crocker? I remembered—someone was saying he had just gotten out of jail—the Sweetheart Twins were talking about him—his nickname was the Crocodile—he was an ice man who liked crank. Fear started sliding around in me again, my best friend, little middle-class Jane had spent the last two days with a murderer. No wonder she was desperately trying to turn it all into a romantic valentine, pulling tinsel and lace out of the garbage of a mind fuck. All I could do was bend over backwards to help her see it any way she wanted to.

216

"Wow, he sounds really sexy. Did he come from the party across the hall?"

"No, he said you sent him."

"Me? I don't even know the guy."

"I thought he was another present from you, you know, like David Murray."

"Jane, I never sent him here; I didn't! How did he get here?"

"What are you talking about? Your friend brought him."

"What friend?"

"The fat one . . . you know . . . the countess, her royal backside, or whatever she is."

"The Duchess?" I screamed. Slam, the last piece of the puzzle fell into place smooth as a deadbolt. But could the Duchess be so clever as to set up my best friend to get back at me?

"The Duchess brought that man here and left him with you? I'll kill her," I started screaming. "What the hell does she think she's doing, that evil bitch, has she lost her mind?" On and on I went but my bowels were turning to water, a sure sign of guilt. I had to blame the Duchess; it was the only way out. Someone had to pay for this and it wasn't going to be me.

The story slid around and got worse and worse; for Jane because she had no idea what was going on, and for me because I couldn't tell her I was sorry. She was too busy crashing like a trooper; from putting on makeup, she went straight to packing her suitcase. Her instincts were right. She was no fool, she was going home. I started to panic. I was sort of counting on Jane's parents paying the rent; without her I would be homeless. Damn it, I thought; one lucky shot and the Duchess had found my Achilles' heel.

Motivated by revenge, bile, and other dangerous stomach acids, I hung on to the bitter end, helping Jane make plane reservations, and dragging her stuff to the corner to hail a cab, saying frightened good-byes. As the cab drove off, my life collapsed like a circus tent; like gray canvas it lay in the street in piles of dirty snow that were beginning to melt. I couldn't go back to our apartment alone, so slapping my own entirely black wardrobe into some garbage bags, I stored them with the girl upstairs and invited the party next door to come on over.

I spent that night at the Cornell dealer's house. I had seen him a couple of times since the night on my parents' roof, but this time he was different: he didn't try to kiss

me. He just kept on talking to me about cleaning up and it made me nervous. "We'll go to Europe where nobody knows us and I'll help you stop. I'll just bring a little stuff to let you down easy, okay? I gotta make a drop in the morning and on my way back I'll buy the tickets, so you wait here for me, okay, and we'll be on the plane tomorrow."

I said yes but I didn't wait. I wasn't leaving my friends for him. The minute he was gone I went to his refrigerator, which was stuffed with little aluminum packets. I got down on my knees and whispered, "Please, God, you fucking monster, take whatever you want, but give me one last fuckin' crack at the Duchess. Just let me see her again, I'm begging you, you prick." I know I should have given up, gone to sleep, gone to Europe, but I didn't. Since the refrigerator before me had enough drugs to march the Red Army, it could certainly lend me the energy I needed. I loaded my system. This time it was brutal.

When I finally found the Duchess it was 2 P.M. and sunny, but I couldn't tell, the sky looked black to me. I was so frazzled, my whole world was in photo negative. To my grim satisfaction people avoided me as I marched from the subway to Rockefeller Plaza. Ingrid had told me that the

Duchess and Andy had been having lunch here, it was their new thing. Fine, the classier the spectacle the better. On the balcony overlooking the ice skating rink, I scanned the place. They were easy to spot; it was after lunch and no one else was there. Andy sat ringside at a table with a pink tablecloth, applauding and laughing over his seafood salad, while the Duchess skated by him, as graceful as a little killer whale. I couldn't believe it. She wasn't just good, she was show class, skating beautifully—backwards, figures, dives, leaps—her great form balanced effortlessly and swooping past me in perfect circles. I couldn't hate her, she was too good; instead I felt condemned, the victim of my own brutal search, when the oddest thing happened. I vanished. I was screaming like an enraged Lucifer but nobody heard, and while Andy ignored me and the Duchess stared straight through me, I was dragged by the attendant out of the icy white ring of heaven.

It was over, I was a ghost, a gray person, just another drug casualty. A line of school kids walked right through me waving their skates. None of them saw me. As I stumbled down the street, it grew to resemble a DC-10 runway that I couldn't cross—cars honked angrily, the daylight burned my skin. Why Miss Smith? Why had the

demons come for me? Their shadows moved through the traffic like birds of prey. I had to find the subway. I needed the darkness, but it didn't save me. The subway seemed to plunge me even further from grace, its windows flashing black and empty like the cells of my brain, all the animals dead or gone. My only hope was to get off on the blackened shores of Brooklyn and not let the ocean drag me any farther out.

The exit of the BMT subway in Brooklyn Heights is guarded by an old church made of red flagstones and surrounded by a heavy black iron gate. Imprisoned behind these gates are five bushes I remember from my childhood, bushes so ugly that you would wonder why they had been planted at all, until one spring day when they blossomed into thousands of yellow flowers called forsythia. As I emerged from the subway my monochrome vision suddenly registered yellow; all five bushes were bursting with flowers. I couldn't understand it. It was midwinter and freezing. Snow was still on the ground. Yet there they were, the color of the scarf Ondine had wrapped around his neck when I last saw him. Had he sent them to say good-bye?

I crumpled to the ground. Neighbors recognized me

and brought my parents. Oh, I could have made it home; you don't get three blocks from your house and not have the strength to go on—it wasn't the drugs that finally brought me down, no, my mind never snapped— something else happened. The brutal yellow forsythia broke into my negative world, and for an instant I stopped thinking of myself and thought of Ondine—thought how he would miss me, which was even more painful than my missing him, and I couldn't help him. I couldn't help anyone: not my mother, or my brother, or even Jane, but suddenly I could feel them. I could feel the victim crouched in Jane's bravery, the jealousy that lay under my mother's fierce protection, and my innocent little brother who would be taking his own drugs very soon. Nothing was hidden, not even the sad man imprisoned in my father's selfishness. It was these opposites that gave them life and they would turn back into cardboard if I returned. Besides, it was too late to go back to Ondine if only to say good-bye . . . and it was good-bye. He had already known it when we kissed in the snow, and I couldn't fool myself any longer. I fully expected my parents to incarcerate me in some drug clinic with a battery of shrinks so that nothing

would ever be the same again. And even if they didn't, nothing would ever be the same.

The ocean had thrown me back onto Brooklyn's shore in pieces and all I could do now was collect and reassemble them into something new.

It would take a little time.

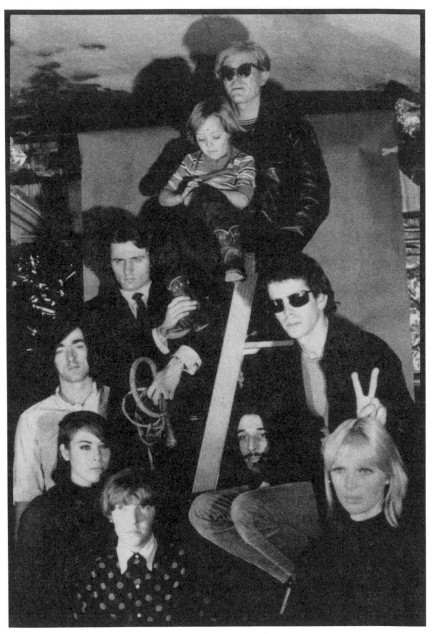

Clockwise from top: Andy Warhol, Lou Reed, John Cale, Nico, Maureen Tucker, Mary Woronov, Sterling Morrissey, Gerard Malanga, Ani, Nico's son.

EPILOGUE

LIKE I SAID, I can also see the future from this chair. I will see Ondine again, years from now. I know, it sounds like I never really did get out of my chair, but I did—I just don't see time in a linear fashion anymore. The past, present, and future roll together in one continuous wave; the beginning swell from out of the deep is the past, the foamy break is always the present glistening in the sun, and the future is the same wave receding, the fear of the end eroding the sand around my ankles.

After they peeled me off the sidewalk in Brooklyn, even I had to admit I could no longer take speed, and, taking off my amphetamine wings, I had to learn to walk like everyone else. I actually did go to Europe with that dealer; I developed a more normal attitude towards men, and I even ended up living in L.A. as an actress. While I was away in Europe, Andy got shot and things weren't the same at the Factory, so there was nothing to go back to. I didn't think about any of the Warhol people until years later when a boyfriend told me that *Chelsea Girls* was playing at the Nuart Theater and it was being introduced

by a guy called Ondine. Only then did the New York snow start to drift through my sunny California sky. I had heard he was living with his mother in Queens and that he made a little money taking Warhol's movies around the college circuit and lecturing, all of which sounded kind of demeaning.

As I listened to Ondine answer the audience's questions, I knew he was the same, only his audience had changed. No longer surrounded by the fabulous chaotic speed freaks, he was adrift on a desolate sea of uncomprehending faces. He seemed older and very alone up there, and suddenly I was afraid they might see him as a ridiculous old fag. I had to suppress my desire to run on stage and drown with him. The minute the movie started I left my seat and rushed into the lobby to find him. There was so much to say.

"How are you? How are you?"

"Well, my dear, how do you think I am? Look at them," he waved his arm at the audience. "Oh, it's not their fault, that they are too stupid to understand, which makes me a sideshow—I can't be anything else, so how do you think I am? I mean, I don't mind, actually, you know, I love

it, but if I can't tell them the simplified version and they can't imagine the real one—what am I supposed to say?"

He really thought he had done a bad job of lecturing and I could tell he was upset. "Ondine, you were brilliant." I tried to apologize for the audience's unenthusiastic response. "They love you, they were just in a state of shock."

His voice curled once again around my heart. "Darling, they are below shock, but why bother preparing the truth for them when lies are so much more appetizing? Which would you rather eat, reality or cheeseburgers?" His eyes were glittering in that old wicked way.

"I don't know . . . reality?"

"There is no reality in history, just versions of manufactured hamburgers. Although in your case, trying to tell the truth would be more revealing."

"No, I want to lie too, incredible fabulous lies."

Ondine's laugh was like the rough purr of a cat. "Ah, so you are still one of us. Then I have come to warn you." He gestured again to the audience, now muffled in the darkness with their eyes glued to the screen. "All those faceless heads will crowd into your brain one day and force

you to explain what happened. It can be extremely embarrassing, isn't that divine? Well, Mary, how are you?"

"I'm fine. I'm, you know, okay. Well, lonely . . . I miss—"

"Ah, my dear, not for long. Here he comes."

"Oh, this is my boyfriend—"

"Yes, I can tell."

"This is Bob. Bob, Ondine."

"I hoped you would be here, Bob. We all used to wonder where you were."

My insecure macho boyfriend was so pissed that I had left him alone in the theater that he wanted to leave immediately, and was I coming or not? Of course, I was going with him, we only had one car. What did he think, that I was going to walk home? So I really didn't get a chance to talk with Ondine. Right, I know what you are thinking—how could I not have had time? How could I have been so in love with some jerk that I couldn't even spend an hour with the Pope? Well, I don't know. I'm just telling you what happened; I'm not saying I like it.

Two years later the Duchess called me from New York to say that Ondine had died of liver disease in Queens. The room got very quiet and empty, but I couldn't really think about it. I had become very adept at not thinking

about things I didn't like. However, that night I could think of nothing else. The voice inside my head would not shut up. . . . Why didn't I stay and talk to him at the Nuart? No, I had to run away, not because my boyfriend was pissed, but because Ondine was a little foolish, a little sad, but a real person and I couldn't deal with it. All that time I knew him he never complained about my putting him in a cage, pretending he was Aeneas, never wanting to know who he really was. Warhol too—I never wanted to know who he was either, and I definitely didn't want to know who I was. Ondine's voice cut into my train of thought.

"Oh please, what you should have done is uninteresting, and what you did is over, so forget it."

"But, Ondine, it was such a disaster."

"A disaster? I thought it was divine."

"No, you're right, it was divine. Ask any of us who survived—Louie, Gerard—the answer always begins with that smile. But it wasn't a happy ending."

"Ugh, the thought of one of those is horrifying—at least we had some dignity."

I stopped whining. "What are you suggesting, Ondine?"

"I would get rid of that cocksucking little rat, that other voice in your head."

"Yeah, and get rid of my boyfriend too."

"No, I like him. Just the rat, my dear, change him into a bird. As your magician I suggest shrinks, meditations, a change of diet, and a lot of standing on your head. Whatever, just shut him up."

I look around, but no one is there. I'm never going to see Ondine again.

It wasn't until I was standing in the bathroom, remembering the time he shot up in his eye, that I felt his presence again. I didn't turn on the light; the moonlight was so bright I could clearly see my face in the mirror. It was like looking out the window onto familiar countryside—two gray eyes balanced like moonlit stones on hillside cheekbones.

I smiled and said out loud, because I knew he was listening, "I am the opposite of Persephone. I wish for winter when I can return to Hades and get high with the Pope."